ideals EASTER

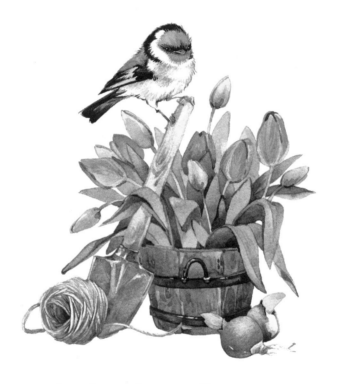

*Another glorious Easter morn
has dawned on us once more,
with promises and brighter hopes
and springtime at our door.*
—Carice Williams

ideals
Nashville, Tennessee

The Daffodils
William Wordsworth

I wandered lonely as a cloud
that floats on high o'er vales and hills,
when all at once I saw a crowd,
a host of golden daffodils,
beside the lake, beneath the trees,
fluttering and dancing in the breeze.

Continuous as the stars that shine
and twinkle on the Milky Way,
they stretched in never-ending line
along the margin of a bay:
ten thousand saw I at a glance,
tossing their heads in sprightly dance.

The waves beside them danced;
 but they
outdid the sparkling waves in glee:
a poet could not but be gay,
in such a jocund company:
I gazed—and gazed—but little thought
what wealth the show to me
 had brought:

For oft, when on my couch I lie
in vacant or in pensive mood,
they flash upon that inward eye
which is the bliss of solitude;
and then my heart with pleasure fills,
and dances with the daffodils.

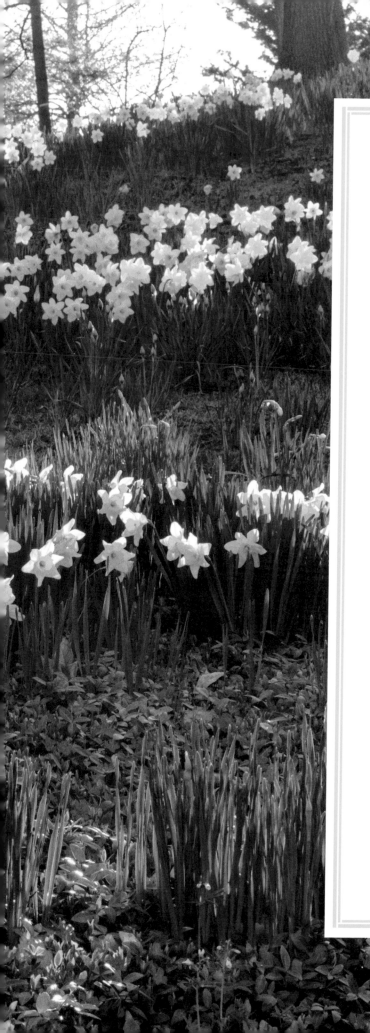

The Waking Year

Emily Dickinson

A lady red upon the hill
her annual secret keeps;
a lady white within the field
in placid lily sleeps!

The tidy breezes with their brooms
sweep vale, and hill, and tree!
Prithee, my pretty housewives!
Who may expected be?

The neighbors do not yet suspect!
The woods exchange a smile—
orchard, and buttercup, and bird—
in such a little while!

And yet how still the landscape stands,
how nonchalant the wood,
as if the resurrection
were nothing very odd!

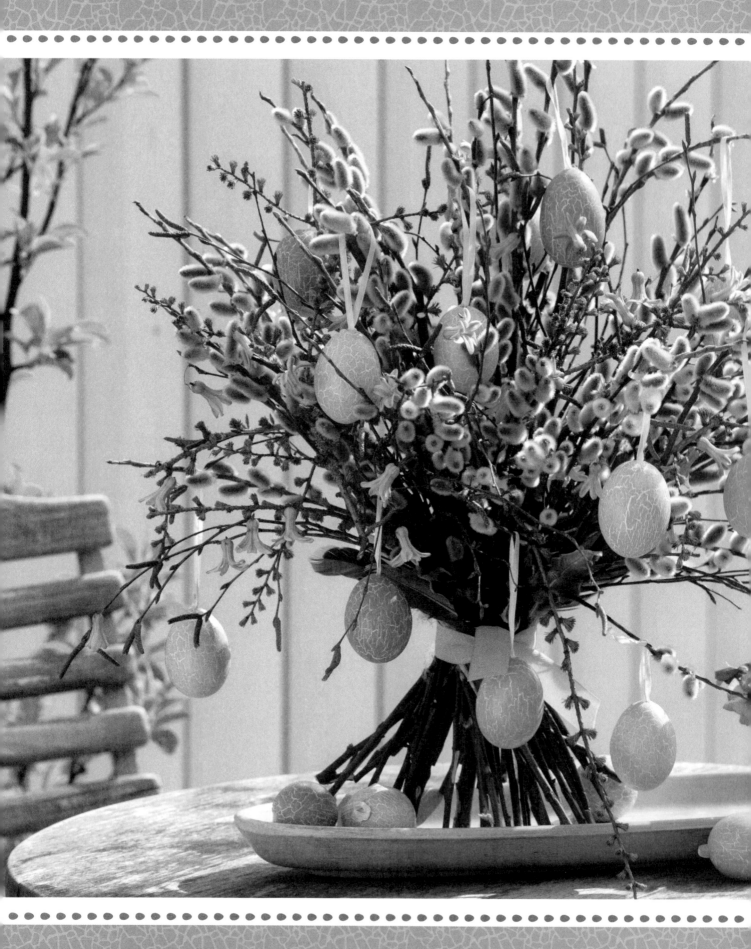

Little Catkins
Peggy Mlcuch

Little catkins in a row
on branches far and near—
thrusting forth soft, furry heads
announcing spring is here.

Bidding all the world awake
for winter's nearly gone—
telling tree and bush and shrub
to greet the bright new dawn.

Pussy Willows Have Arrived!
Georgia B. Adams

The pussy willows have arrived!
These plushy kittens sweet
come early in the month of March;
they come with padded feet.

Scarcely you hear them, for these cats
do not meow or cry;
they like to cuddle on the stems
and breathe a purring sigh.

And see how long those gallant stems!
They sway with every breeze;
unlike all kittens that I know,
they're never climbing trees!

The pussy willows have arrived . . .
these cushions on a stem
are glad harbingers of spring;
I love the sight of them!

Image © Friedrich Strauss/GAP Photos

Spring Peepers: A Day of Small Things

Joan Donaldson

On a morning in March, when sunshine is melting the snow on the barn roof and rivulets flow down our muddy driveway, I hear him. A tiny *creek, creek* ripples up from the pond behind our house, and a shiver runs down my back. For the past week, my ears have sorted through the birdsongs of the tufted titmice and chickadees, hoping to hear this sound.

While the psalmist who penned Psalm 8 gazed upward, marveling at the stars and the moon created by God, the writer of Zechariah 4:10 reminds us not to despise the day of small things. Sometimes looking down reveals tiny gifts.

Somewhere near our pond, a diminutive frog known as a spring peeper has endured winter's freezing temperatures. Today, he awakens and wiggles from underneath a log or from his shelter behind a tree's bark. Sitting beside a cattail stalk or a clump of brown grass, he proclaims that spring is creeping onto my farm. His vocal sac expands to almost match his inch-and-a-half length, and the bell-like *creek* travels a quarter mile across fields and orchards. Just as I noted the return of the robins and bluebirds, I have longed to hear spring peepers proclaim that winter is over. Soon warm showers will green the grass and leaf buds will swell.

Once, when I was a child, my family hiked in a nearby park. Binoculars dangled from our necks as we looked for returning songbirds. Hearing spring peepers singing near the path, I paused at a large puddle. Somewhere in the low, wet spot, peepers had called until they heard or felt our footsteps; then their voices hushed. With determination, I squatted down and watched. Nothing. A downy woodpecker hammered on a nearby tree trunk. A nuthatch darted overhead. No little frogs peeping.

"I'll run and catch up," I told my parents, and they ambled down the trail.

Stillness. The scent of wet dirt and molding leaves drifted about me as I focused on the puddle. Finally, one peeper piped up. I scanned the surface of the water, searching for movement. Another *creek* rippled from a half-submerged leaf. I hunkered down and spied his expanding vocal sac as the peeper sang again. For the next few minutes, I barely breathed as the little guy called out. He bore a small brown cross on his back and had oversized feet. Later, I learned his large footpads helped him climb trees. Eventually, I raced off and rejoined my parents.

Now, from our pond, another peeper sings along with his friend. Soon a full chorus is belting out their tune about warm weather and wood ducks nesting in trees. In their small way, the peepers remind me of the words Isaiah wrote: "You will go out in joy and be led forth in peace . . . and all the trees of the field will clap their hands" (Isaiah 55:12 NIV). I would add the voices of these wee amphibians to those sounds of joy.

A sudden snow shower or frosty night will silence the little fellows, but in the morning, the sun will revive them. Throughout early spring,

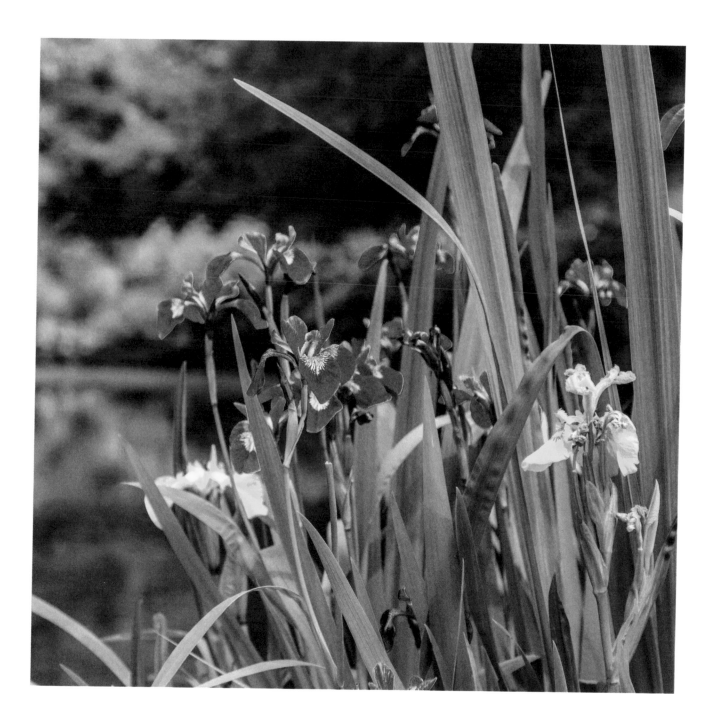

they drone on, one of the strands in a fugue created by peepers, migrating birds, and the southern breezes rippling over our hay fields.

Then some morning, while hanging out laundry, I realize our pond is quiet. The peepers have completed their spring fanfare. They have hopped off to the nearby bog or the edges of the woods.

While summer will bring the trill of tree frogs, the call of the oriole, and the music of rustling oak leaves, none of these notes matches the thrill of hearing the silver call of the first spring peeper.

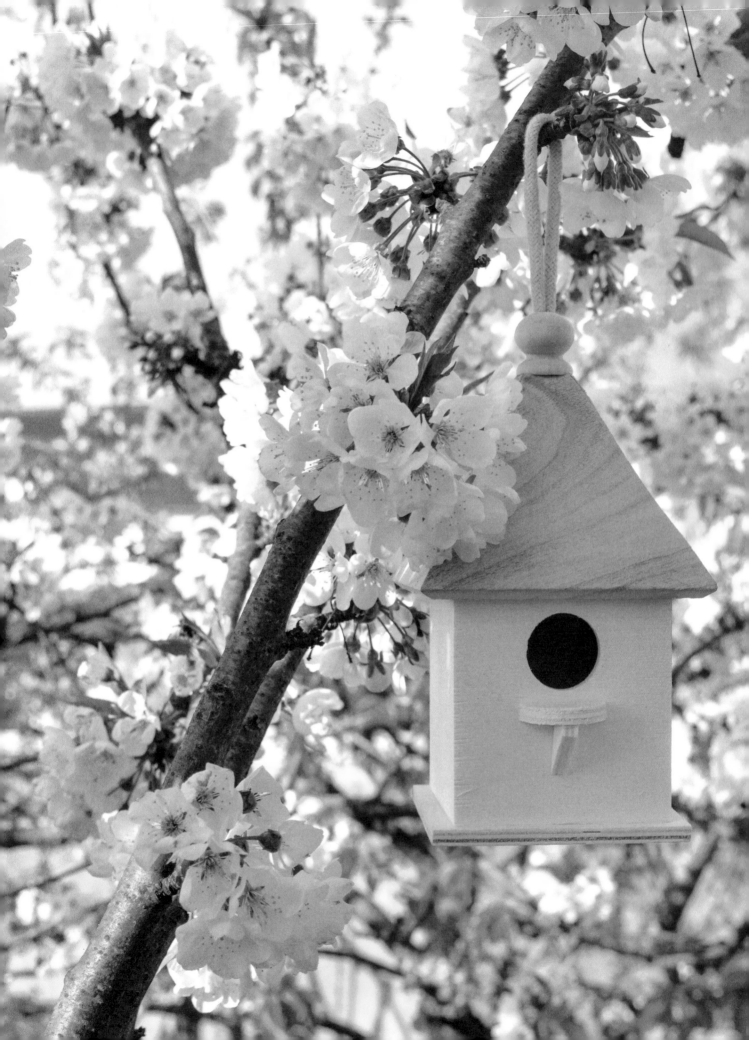

Fiddlehead and Robin
Susan Sundwall

A tiny curled-up fiddlehead
tucked 'neath the melting snow
awakened one fine morning
when a robin chirped, "Hello!

It's time to rise, you sleepyhead!"
and then began to sing.
Robin and the fiddlehead
rejoiced in God's new spring.

A Spring Day
Carol Dismore

A robin breaks the silence first
as color fills the sky.
A piccolo cacophony
sings out in loud reply.

As dawn progresses, meadowlarks
run up and down their scales.
And magpies balance on a branch
in long tuxedo tails.

As meadow flowers sun themselves
in air washed clean by spring,
persistent trickles run from rocks,
where crusty snowbanks cling.

Beyond the rocks, the mountains rise
in peaks of lacy white

to shade the meadow early
when the sun goes down tonight.

While butterflies delight in sunshine,
dancing on the flowers,
bumblebees make haste the few
remaining daylight hours.

As shadows lengthen, melting
into twilight's open sky,
the evening star winks joyfully,
a silent lullaby.

In cooling air, the snowmelt slows
as evening fades away,
and quiet settles over all
to crown a perfect day.

Spring Renewal

Lansing Christman

Easter turns the renewed life of springtime into spiritual symbolism of the Resurrection. It is a time of blessed joy and a renewal of our faith in eternal life.

After a winter of rest, it is something to behold when new life comes back to the land. You can witness the rebirth everywhere about you in blossom and birdsong and new leaf and greening grass.

God's creation is evident in all things, such as the golden sunrise over the eastern hills, which marks the coming of a new day just as it has been doing since the beginning of time. I meditate on all that I see and hear, in all that I feel so devoutly within my being.

The gold of spring is a fresh, new gold, tender in all its loveliness, different from the autumn gold of goldenrod and falling leaf. The forsythia's yellow blooms form a dome of gold in our yard. A couple of bushes we transplanted at the edge of the woods a few years ago shine as golden as the spring sun. The gold of the dandelions spread like a ray of sunshine in the green grass. The sunshine brightens the daffodils in the flower bed and highlights the gold of the marsh marigold in the swamp.

The birds sing with joy in celebration of the new life around them—robins and bluebirds, red-winged blackbirds with their scarlet epaulets, mockingbirds, cardinals, and white-throated sparrows. The rose-breasted grosbeak, which sports a rose-red triangle on its breast, flits through the trees. Accompanying the birdsongs are the tinkling waters of a hillside stream, gently trickling through the seams of the earth. And from the swamps the spring peepers pipe their chords like a chorus of shrill bells, announcing the glory of renewed life.

This is a time for the spiritual celebration of the Resurrection. Easter is God's promise of everlasting life to all who put their trust and faith in our Lord and Savior, Jesus Christ.

HOME BY THE SEA *by Randy Van Beek. Image © Randy Van Beek/Art Licensing*

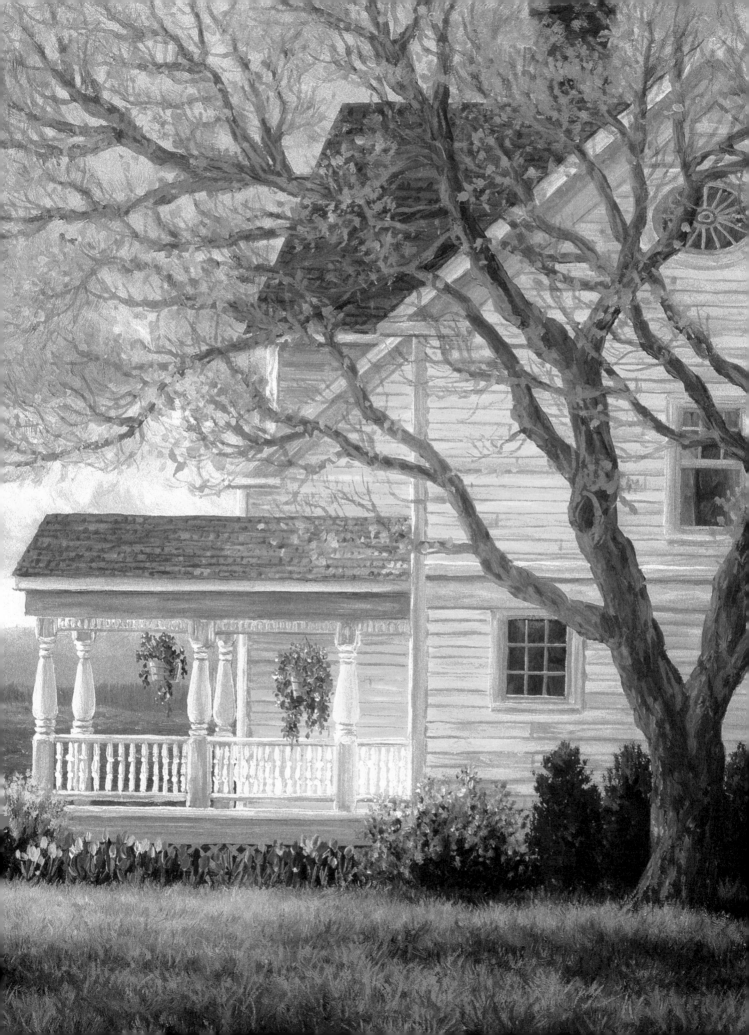

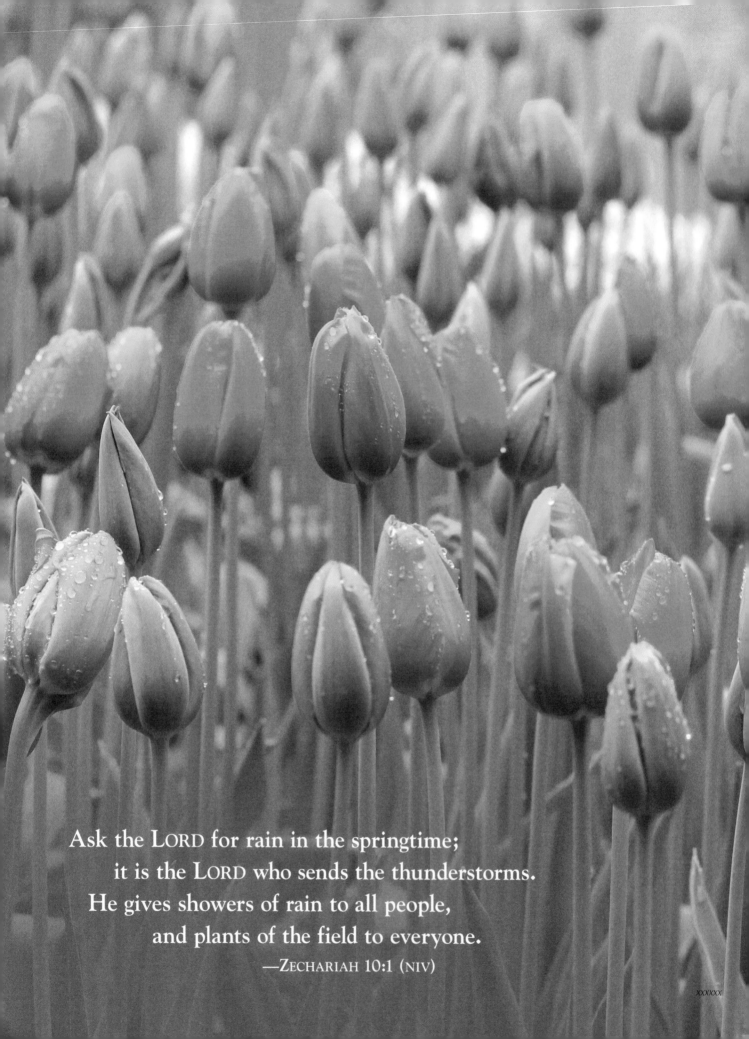

Ask the LORD for rain in the springtime;
it is the LORD who sends the thunderstorms.
He gives showers of rain to all people,
and plants of the field to everyone.
—ZECHARIAH 10:1 (NIV)

The Rains of Spring
Lady Ise

The rains of spring,
which hang to the branches
of the green willow,
look like pearls upon a string.

Spring
Susan Andrus

Rainlets on the
 window,
sweetness in the air,
children jumping
 puddles,
spring is everywhere!

Breezes gently blowing,
pansies turn their
 heads,
flowers softly open
in their earthy beds.

Little feathered parents
build a grassy home,
lovingly preparing
for families of
 their own.

Days of warmth
 and sunshine,
joy is in the air.
Hearts are skipping
 lightly—
God is everywhere!

Image © Petr Pohudka/Shutterstock

Family ~ Recipes

Candy Bird's Nests

1 12-ounce package milk chocolate chips
1 12-ounce package butterscotch chips

1 12-ounce package chow mein noodles
48 to 72 candy-coated chocolate eggs

In a large microwavable bowl, pour milk chocolate and butterscotch chips. Microwave on high for 30-second increments just until melted; stir until smooth. Add chow mein noodles and toss until completely coated in choco-late mixture. Drop by rounded table-spoon onto parchment paper; carefully shape each into a nest. Place 2 or 3 candy eggs on top of each nest. Allow nests to set until firm. Makes 24.

Springtime Crinkle Cookies

1 15.25-ounce box white cake mix
⅓ cup vegetable oil
2 eggs

¼ teaspoon lemon extract
 Food coloring
 Confectioners' sugar

In a large bowl, combine cake mix, oil, eggs, and lemon extract; mix well. Divide dough into as many sections as you would like colors of cookies. Add food coloring to each section of dough as needed to achieve springtime colors. Cover dough with plastic wrap and refrigerate 2 hours.
 Preheat oven to 375°F. Form dough into 1½-inch balls and roll generously in confectioners' sugar, making sure to cover all sides. Place each cookie on a parchment-lined baking sheet 2 inches apart. Bake 7 to 8 minutes. Cool on bak-ing sheet 1 minute; transfer to cooling rack and cool completely. Makes 24 to 36 cookies.

Mini Lemon-Blackberry Cupcakes

1½	cups all-purpose flour	
¾	teaspoon salt, divided	
¼	teaspoon baking powder	
¼	teaspoon baking soda	
6	tablespoons plain yogurt	
⅓	cup lemon juice	
1½	tablespoons lemon zest	

1	cup plus 2 tablespoons unsalted butter, softened, divided
1	cup granulated sugar
3	medium eggs
1¼	cups confectioners' sugar, sifted
¼	cup blackberry jam
	Fresh blackberries (optional)

Preheat oven to 350°F. In a medium bowl, sift flour, ½ teaspoon salt, baking powder, and baking soda. Whisk together thoroughly; set aside. In a medium bowl, stir together yogurt, lemon juice, and lemon zest; set aside. In a large bowl, cream ½ cup butter with sugar until light and fluffy. Add eggs one at a time, beating between each addition. Add flour mixture alternately with yogurt mixture, ending with flour and beating at low speed until well combined. Spoon the batter into mini-muffin pan lined with paper liners, filling each nearly to top. Bake 11 to 13 minutes, rotating pan halfway through, until toothpick inserted in center of a cupcake comes out clean. Remove from oven and cool completely on wire racks.

In a medium mixing bowl, combine 10 tablespoons butter, ¼ teaspoon salt, and half of confectioners' sugar; beat until smooth. Add blackberry jam and remaining confectioners' sugar. Beat until light and fluffy, 2 to 3 minutes. Place in a piping bag and pipe frosting on each cupcake top, starting from outer edge and spiraling toward center. Top each cupcake with fresh blackberry, if desired. Makes 36 mini cupcakes.

Sweet Memories of Easter

Michael Heaton

When we were kids, Easter Sunday was all about the Resurrection of our Lord and Savior. But when we were still in the single digits, the candy ran a very strong second. In fact, I remember thinking that was the first thing Jesus did when He rose from the dead: He invented candy. Candy and that cellophane grass that has a shelf life on par with radioactive waste. Only God could make something that indestructible.

But I could never get my head around the custom of coloring hard-boiled eggs. I guess they are festive. But hard-boiled eggs are like the anti-candy. It's like wrapping brussels sprouts in gold foil. Once you peel off the dyed shell, you see the discolored egg underneath. The only good thing a person can say about all those eggs is that they can be made into egg salad.

But even the best egg salad in the world is never going to win a popularity contest with chocolate. Specifically, the two-pound solid chocolate bunny from Sell's candy store that was down the street from our house. That bunny seemed so dense that, at first, we could only make scraping teeth marks, whittling the ears and head until it got to the point you could actually snap off a piece.

All during Lent we would gaze dreamily into the storefront window of Sell's, where, among all the Easter basket items, there was a human-size chocolate bunny. This was especially enticing because we always gave up candy for Lent. (I mean, what other vices do kids have?)

There was always a giant jar of jellybeans inside Sell's with a contest to guess how many were in there. My guess was always ten million. I don't remember what the prize was or ever knowing anyone who won. It seemed like a scam if ever there was one.

Back then, jellybeans were huge compared with the tiny gourmet jellybeans of today. And they were sugary rather than fruit-flavored. They were color-flavored. Red, green, yellow—not mango, watermelon, or star fruit. Large, chunky crystals of cavity-inducing sugar. Those jellybeans kept the dentists in high cotton for a generation.

Jellybeans were like the appetizers for a five-course candy experience. Except, of course, for the dreaded black licorice jellybean. As soon as the Easter baskets had been discovered, I would begin a clandestine campaign against my four sisters to exchange my black jellybeans for any other kind in their supplies. By using all four of their baskets, my distribution of the unwanted black jellybeans was less obvious. I was the evil genius of Easter candy theft.

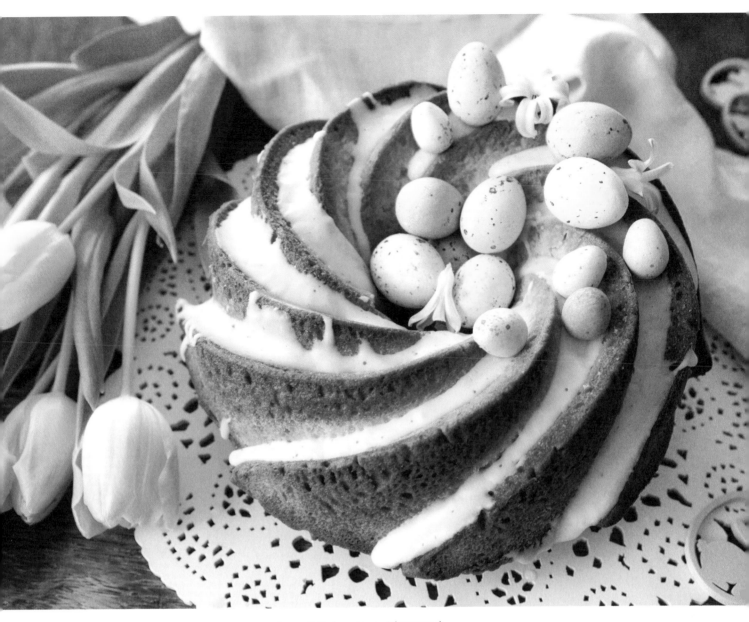

The yellow marshmallow Peeps were a nice diversion when the gnawing of the chocolate bunny head became too tedious and jaw-ache set in. Peeps had the distinction of actually getting better when they were a little stale. And talk about sugary! They should come with insulin.

Today they manufacture Peeps of every flavor and for every holiday. There are Halloween Peeps and Presidents' Day Peeps. They're less special now. Back then, life was simpler. Peeps were as much a symbol of Easter as was the canned ham with that hideous gelatin on it for our holiday dinner.

My secret favorite candies were the chocolate-covered malt balls coated in a white candy shell to make them look like small Easter eggs. One of my sisters discovered that if you licked the white candy coating, you could give yourself giant, white clown lips. That was always good for an hour's entertainment around the house, scaring unsuspecting adults with what seemed like a bizarre lip condition. One that might have developed from eating too many hard-boiled eggs.

*Bunnies are cuddly,
the large and the small.
But I like chocolate ones
the best of them all.*

—Author Unknown

Hunting Easter Eggs
Mabel F. Hill

We will hunt for Easter eggs,
pretty, colored Easter eggs.
We'll fill our baskets nice and full,
early Easter morning.

Fill each basket to the top,
to the top, to the top.

When it's full, then you must stop,
early Easter morning.

Hunting Easter eggs is fun,
lots of fun, loads of fun.
We'll find eggs for everyone,
early Easter morning!

Easter Surprise
Rebecca Barlow Jordan

Colorful baskets, filled to the brim
with eggs of purple and blue,
yellow, orange, green, and red,
along with a book or two;

children's toys for fun and games
with candy tucked away,

cushioned on top with pillows of grass,
wait for Easter Day.

And one by one across the miles,
little children rise,
their eager hands can't wait to touch
and hold their Easter surprise.

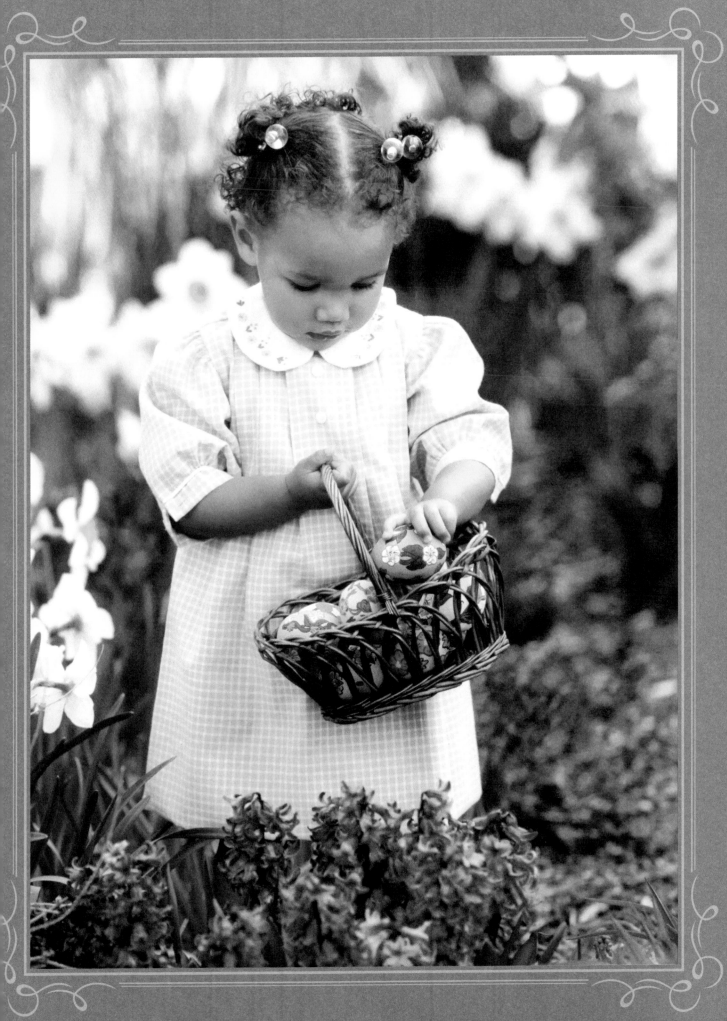

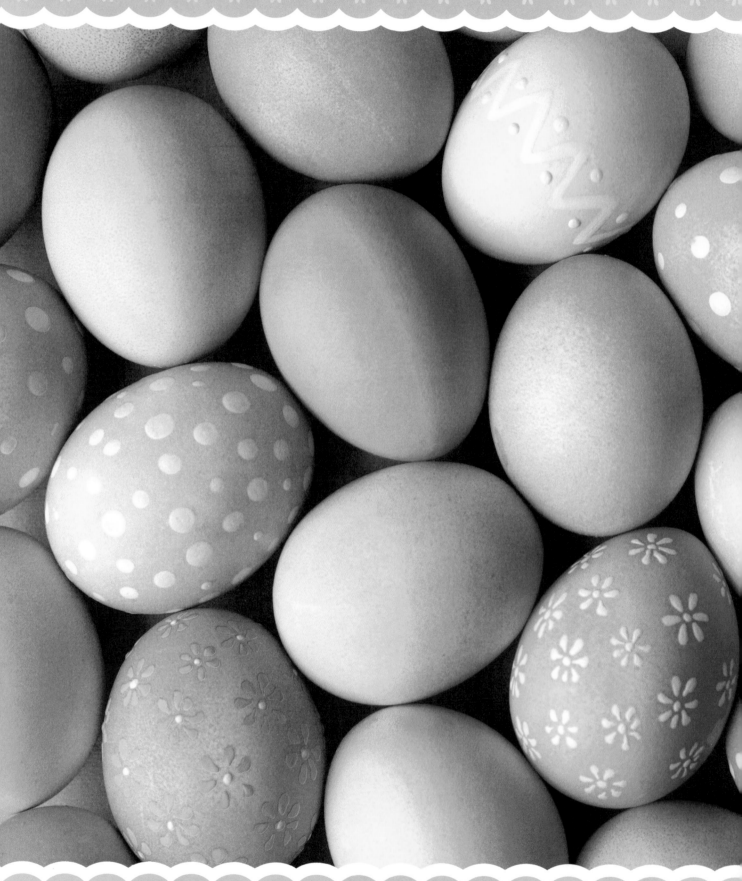

The Easter Eggs

Marjorie Holmes

Well, dear," your husband says heartily, heading for the store, "I suppose I ought to get a few extra dozen eggs."

"Couldn't we skip that part this year?" you plead, remembering previous nights of Easter egg coloring. "Let's settle for the candy kind. That's what they really like best. At least to eat."

"You mean not color any? Why, Honey, it wouldn't be Easter unless we did that. I mean—you and I."

You laugh and say, "Okay, I guess it wouldn't." And you remember how your parents used to stay up half the night playing at being artists, painting eggs with watercolors. And you remember the years you and your husband have perched side by side at kitchen counters dipping those pesky white ovals and tracing names and little messages with crayons and exclaiming over each other's cleverness. And how they always smell so good that you invariably peel a couple and eat them with salt and pepper before you go to bed.

And you guess there is something about an egg—an old-fashioned, elementary, hen-laid egg—that has something to do with the basic values of Easter and that reflects its true significance far more than baskets and bunnies and jellybeans ever can. Because, no matter how you fancy it up, there is nothing artificial about an egg.

Maybe that's why, even if they don't eat them, children want to touch them and hold them and work with them and find them in nests along with everything else on Easter morning. An egg, like the grass and flowers and birds that have suddenly burst into being all about us, is directly related to life and newness. An egg is the very beginning.

Image © Africa Studio/Shutterstock

A Joyful Easter
Gertrude Kline

There is something about Easter—
its peace and calm delight—
that lingers like the perfume
of a flower fair to sight.

It comes when barren Winter
lets loose his grip on earth

and brings a resurrection
to growing things—new birth.

Some holidays bring laughter,
but the day of which I sing
is the lovely, gladsome Easter
heralding the birth of spring.

Be Glad and Full of Joy Today
Laura E. Richards and Stanley Schell

The little flowers come from the ground
at Eastertime, at Eastertime.
They raise their heads and look around
at happy Eastertime.

And every little flower doth say,
"Be glad and full of joy today,
for all that sleep shall wake again
and spend a long, glad Easter Day."

Then waken, sleeping butterflies,
at Eastertime, at Eastertime.
Go, spread your downy wings, and rise
at happy Eastertime.

And these bright creatures seem to say,
"Be glad and full of joy today,
for all that sleep shall wake again
and spend a long, glad Easter Day."

Image © Robert Mabic/GAP Photos

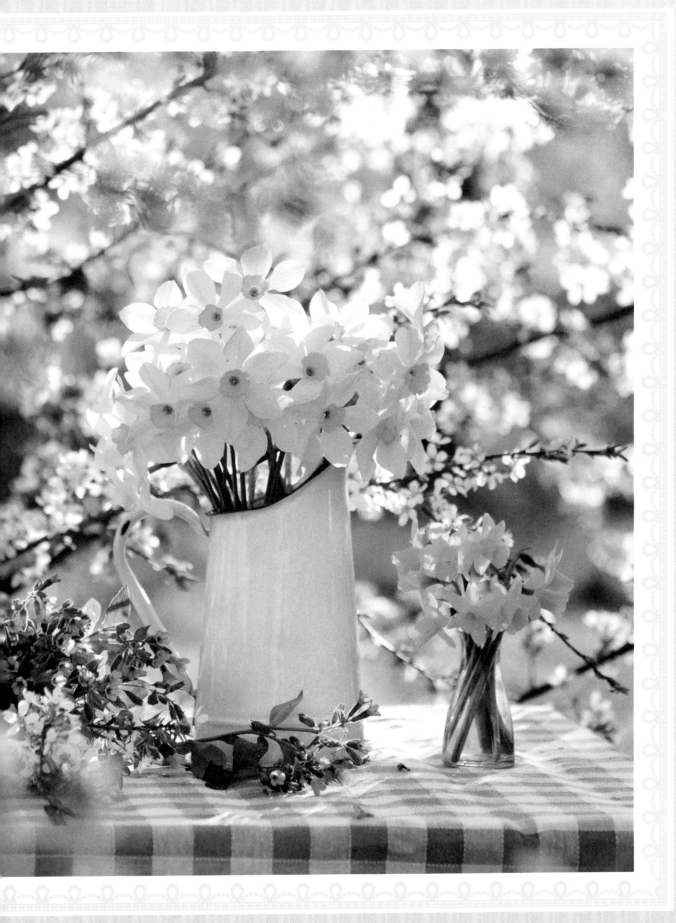

Ring Loud, O Easter Bells
Beatrice Harlowe

Ring loud, O bells of Easter, your peals through spaces ring;
with joy the fair earth greets you through all the notes of spring.
Ring in all peace and gladness; ring out all strife and tears,
as downward through the ages you've rung the passing years.

Ring clear, O bells, your message throughout all nature thrills;
it all things living touches, as when from Judah's hills
there rose a light triumphant o'er death and mortal fears
and dawned that first great Easter—the Easter of the years.

Ring sweet, O bells, your lesson unto each heart today
that all before the Master may but life's lilies lay.
Ring soft, ring low; your chiming may bridge some past—its tears,
for those, perchance, who mourneth some Easter in the years.

Again, O bells of Easter, ring out in thrilling peal
that we, through all our pulses, the newborn
 glory feel;
God's living, loving presence, as each
 new spring appears,
in all that breathes around us,
 throughout the march of years.

Church Bells
Florence K. Snethen

The sound of church bells
 ringing
early on Easter Day
is calling us to worship,
each in his chosen way.

They remind us it is time,
in any kind of weather,
to gather at our church
and as Christians be together.

We listen to the message
and hear the choir sing,
joining in the hymns and prayers—
what happiness they bring!

Here's hoping we will never
forsake with church bells ringing;
they seem a part of Easter
as much as sermons and
 hymn singing.

CHURCH ON THE HILL *by Bill Saunders. Image © Bill Saunders Fine Art*

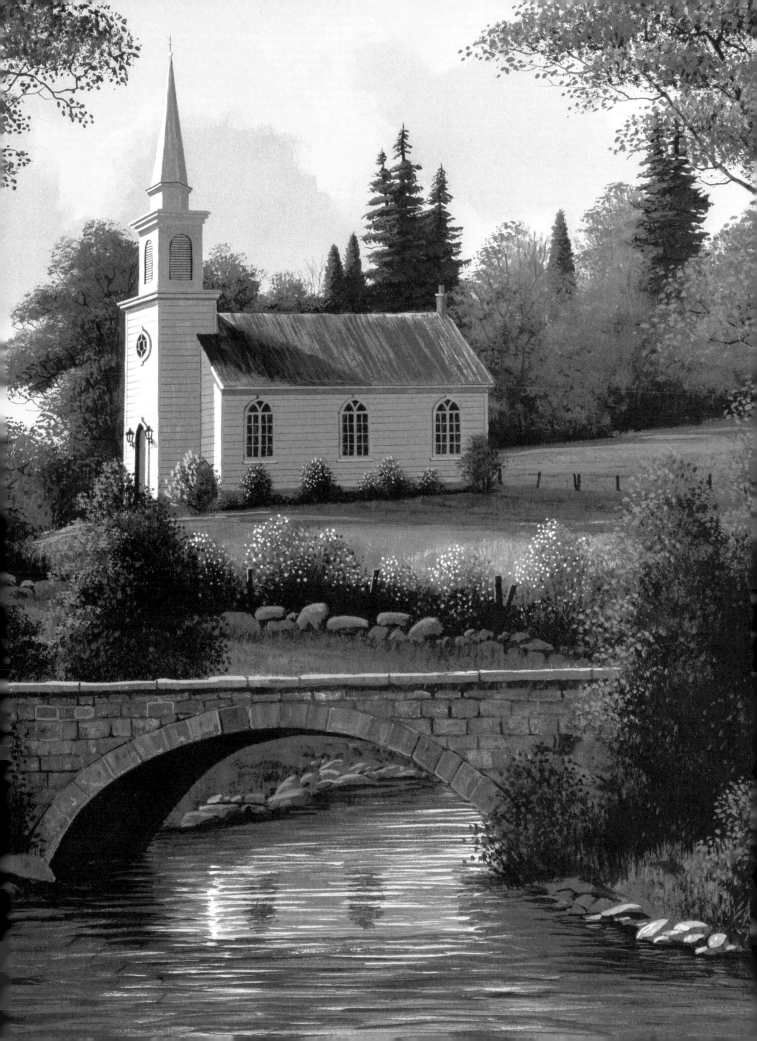

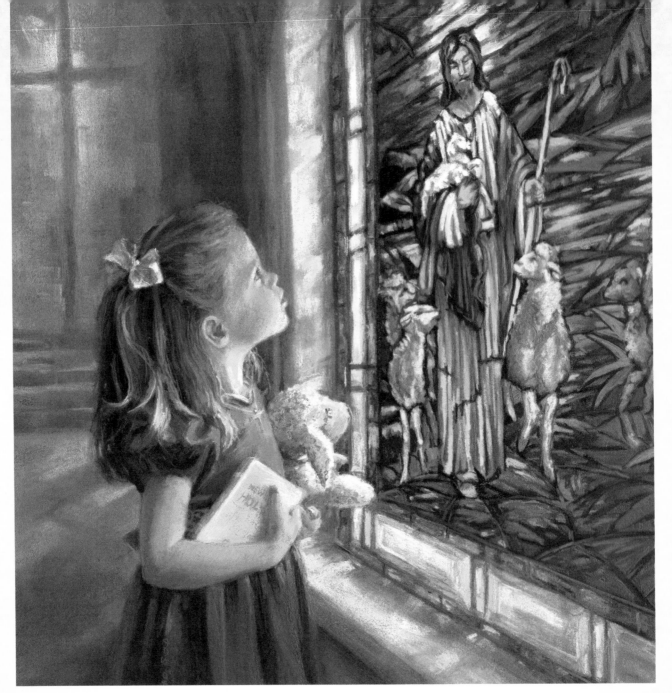

FEED MY SHEEP by Kathy Fincher. Image © Kathy Fincher

The Three Crosses

Clara Brummert

Recently I was sipping coffee and enjoying the morning paper when I spied the first crocus out in the yard. The delicate flower awakened precious memories of an Easter Sunday years ago, an Easter when my youngest granddaughter's innocent, childhood faith strengthened my own.

On that day, she flounced up the porch steps in her new pink dress and presented me with a crocus that she'd plucked from the yard. She gig-

gled when I put the flower in a jelly jar and placed it in the center of the table. Delighted with her contribution, she helped me set the table for breakfast by putting a spoon at each place.

The rest of our big family eased in, and she pulled her chair close to mine before we said grace and passed around a breakfast casserole and basket of hot-cross buns.

The women hurried to wash the dishes before the late-morning church service, and I slid the ham into the oven and then went in search of my purse. I stopped short when I passed through the living room. My granddaughter sat spellbound in a recliner with the devotional magazine I'd left open on the end table resting in her lap.

She stared at a picture of Jesus on the cross. He seemed to make eye contact as He gazed out from the page.

"He's looking at me!" my granddaughter said in awe. "Can He see me?"

"He can see all of us, Sugar Pie," I said and wedged myself in beside her.

She studied the page more intently. "He has boo-boos on his hands." Her tiny finger slid down the page. "And His feet."

I hoped my words would be adequate. "Jesus loves us all so much that He took our punishment so we can go to heaven."

She turned to me with wide eyes. "He was in time-out? For everybody?"

I smiled and nodded as we headed to the car.

At church, the fragrance of Easter lilies settled down around us. The choir sang beautifully, and bright sunlight brought the stained-glass windows to life. The crucifix beneath the vibrant

front window soon captured my granddaughter's attention.

She reached up with a cupped hand and whispered into my ear. "He can see me again!"

"He loves to watch over you," I said softly.

She sighed and leaned back on my shoulder.

I gathered her close, and her head rested near my cross necklace. She reached up and ran a finger over the smooth surface of the cross, empty of our Savior's holy body. For a moment, she seemed confused, and then she whispered her revelation: "Jesus is in heaven, Gram."

I had no words and could only kiss her hair.

Later that evening, I tidied the house. As I stooped to retrieve a stray plastic egg, I was drawn again to the face of Jesus in the magazine. Despite the pain etched in His features, His soft eyes offered an invitation as well as a promise. My young granddaughter had seen both.

I wandered back through the hall, unclasped the cross necklace and gently returned it to its place beside a crucifix pendant. The mysteries of His death and Resurrection lay side by side in my jewel box. That morning my granddaughter had accepted both without question.

As I said my evening prayers, the gentle night closed around me like a favorite quilt. The day had been delightful, and I whispered my thanks. I drifted off, still pondering God's wisdom and timing. Perfectly, by way of three seemingly casual encounters with a cross, He had allowed the greatest love story ever known to become a part of my granddaughter's heart.

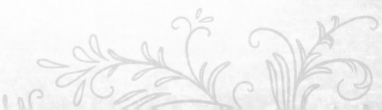

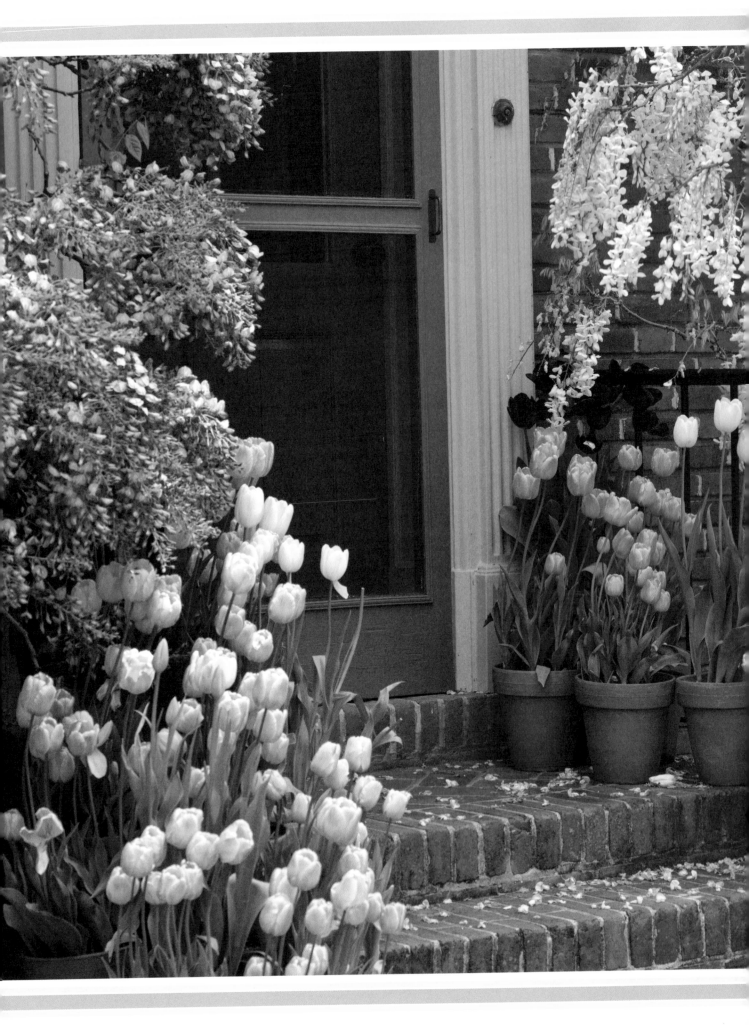

Easter in Our Midst

Jeris Hamm

My Easter Day started at six a.m., and I was not happy about it.

Don't get me wrong—I love Easter. I love the glorious remembrance of Jesus' life on earth and His overwhelming victory. I love the startling reminder of new life as dogwoods burst into legendary white blooms, azaleas blush in myriad shades of pink, and vines of wisteria mist the air with heavenly fragrance.

But this year I'd grumbled all week because I dreaded getting up at dawn to attend early services at our church. As a choir member, I'd been asked to sing at both the eight and ten o'clock services, with classes squeezed in between.

I'd wanted my Easter Sunday to be smooth and easy—not hurried and stressed, requiring extra effort on my part.

So when I awoke on Easter morning right at six, I was already in a bad mood. As I started to dress, I couldn't find my new hosiery. Had I left my stockings in the car after I'd returned from the store? I rushed down the stairs from my bedroom and pushed through the squeaky door of our screened-in porch.

The door snapped shut behind me as I bounded onto the sidewalk. As I moved along the smooth stones, I looked up and slowed to a stop.

A brilliant sun peeked just above the horizon through the trees next to our home. The light illuminated an early morning mist shrouding new growth of wildflowers and saplings. Birdsong pierced the quiet morning. I inhaled the scent of dewy emerald grass and flowering trees.

I thought, *this must be what the first Resurrection morning was like.*

It was as if a sacred celebration was unfolding all around me. In the midst of my hurried schedule, God slowed me down. The breathtaking beauty of the day revealed His presence.

I appreciated anew why the country churches of an earlier generation enjoyed sunrise services. I didn't want to leave that holy moment. As I finally turned back to the house, I decided to stop stressing about trivial things. I never found my hosiery. I silenced my grumbling and simply enjoyed the day.

Later that morning, our church services progressed as smoothly and sweetly as a basket of Easter chocolates. The day belonged to God. He could take care of the challenges in my life, large and small. I was reminded once again of his loving direction: *Be still, and know that I am God* (Psalm 46:10).

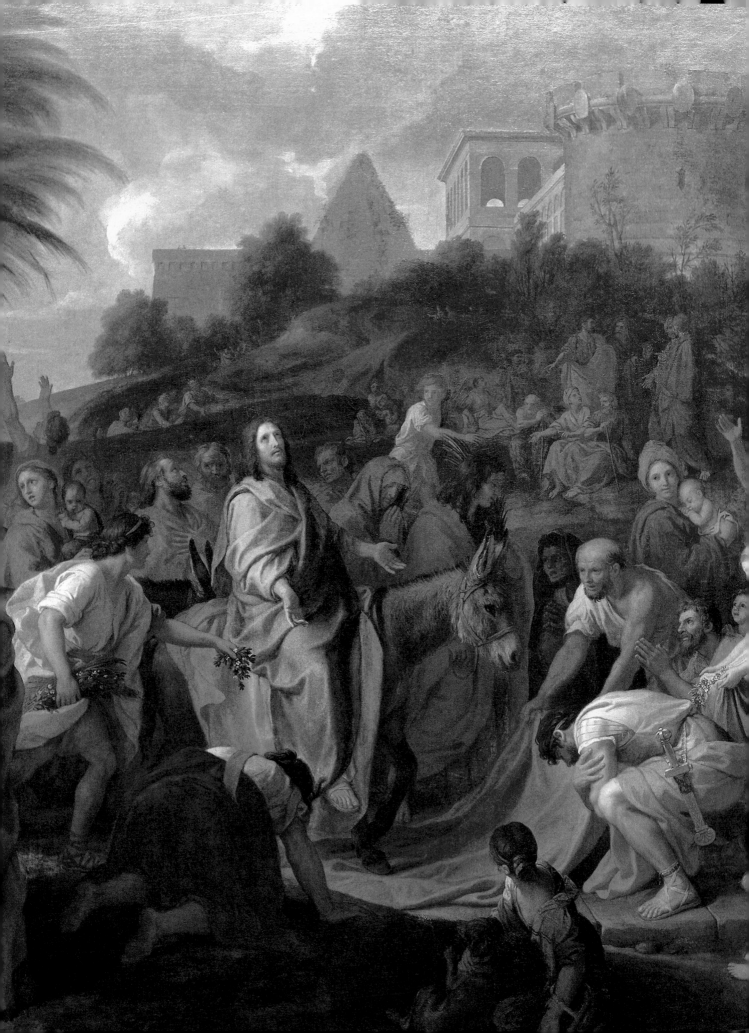

Palm Branches
Minnie Klemme

Do you remember when Jesus came
to Jerusalem that day,
how the people, rejoicing, were glad
and strew palm branches along the way?

Do you recall Gethsemane
and the olives' darkened shade,
how they alone kept watch with Him—
the night that Jesus prayed?

And can you see the thorns He bore
on distant Calvary?
Each thorn that pierced His gentle brow
made sure the souls of you and me.

Yes, I remember the thorns He bore,
and I've learned with the Savior to pray.
And I am glad, I am glad for Jerusalem—
and the palms that were strewn that day.

Hosanna, Loud Hosanna
Jennette Threlfall

"Hosanna, loud hosanna," the little children sang;
through pillared court and temple, the lively anthem rang.
To Jesus, who had blessed them close folded to His breast,
the children sang their praises, the simplest and the best.

From Olivet they followed, a happy, joyous crowd,
the vict'ry palm branch waving, with praises clear and loud.
The Lord of earth and heaven rode on in lowly state,
nor scorned that little children should on His bidding wait.

"Hosanna in the highest!" that ancient song we sing,
for Christ is our Redeemer, the Lord of heav'n—our King.
O may we ever praise Him with heart and life and voice
and, in His holy presence, eternally rejoice!

THE GARDEN

Luke 22:39–54

And he came out, and went, as he was wont, to the mount of Olives; and his disciples also followed him. And when he was at the place, he said unto them, Pray that ye enter not into temptation.

And he was withdrawn from them about a stone's cast, and kneeled down, and prayed, Saying, Father, if thou be willing, remove this cup from me: nevertheless not my will, but thine, be done.

And there appeared an angel unto him from heaven, strengthening him. And being in an agony he prayed more earnestly: and his sweat was as it were great drops of blood falling down to the ground.

And when he rose up from prayer, and was come to his disciples, he found them sleeping for sorrow, And said unto them, Why sleep ye? rise and pray, lest ye enter into temptation. And while he yet spake, behold a multitude, and he that was called Judas, one of the twelve, went before them, and drew near unto Jesus to kiss him. But Jesus said unto him, Judas, betrayest thou the Son of man with a kiss?

When they which were about him saw what would follow, they said unto him, Lord, shall we smite with the sword? And one of them smote the servant of the high priest, and cut off his right ear.

And Jesus answered and said, Suffer ye thus far. And he touched his ear, and healed him.

Then Jesus said unto the chief priests, and captains of the temple, and the elders, which were come to him, Be ye come out, as against a thief, with swords and staves? When I was daily with you in the temple, ye stretched forth no hands against me: but this is your hour, and the power of darkness.

Then took they him, and led him, and brought him into the high priest's house. And Peter followed afar off.

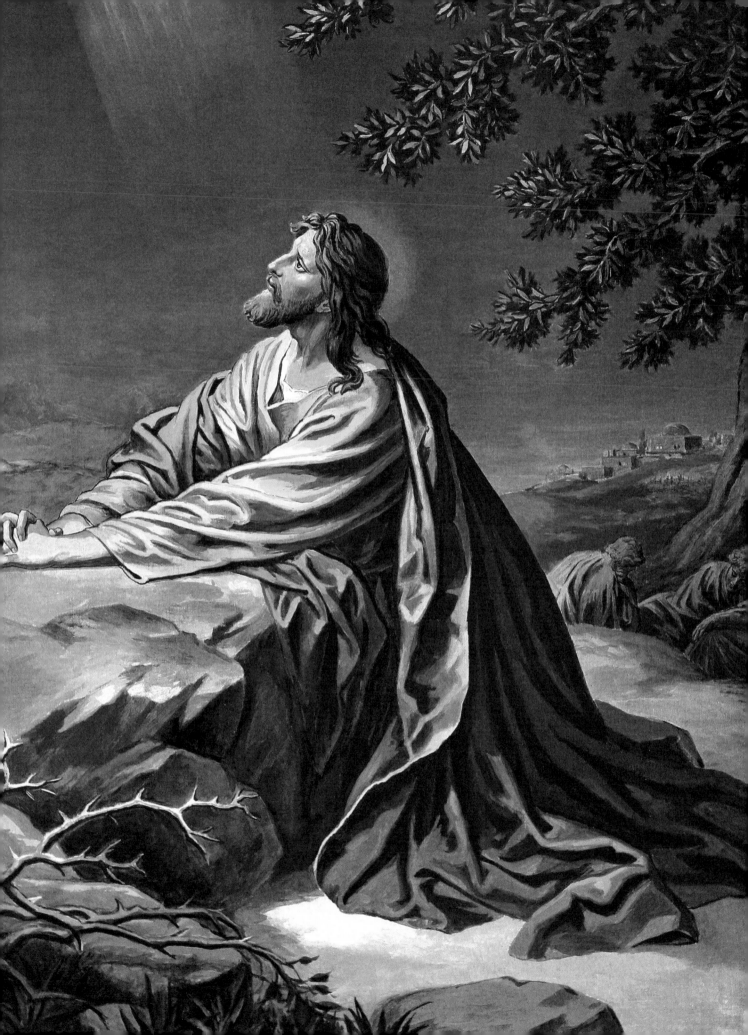

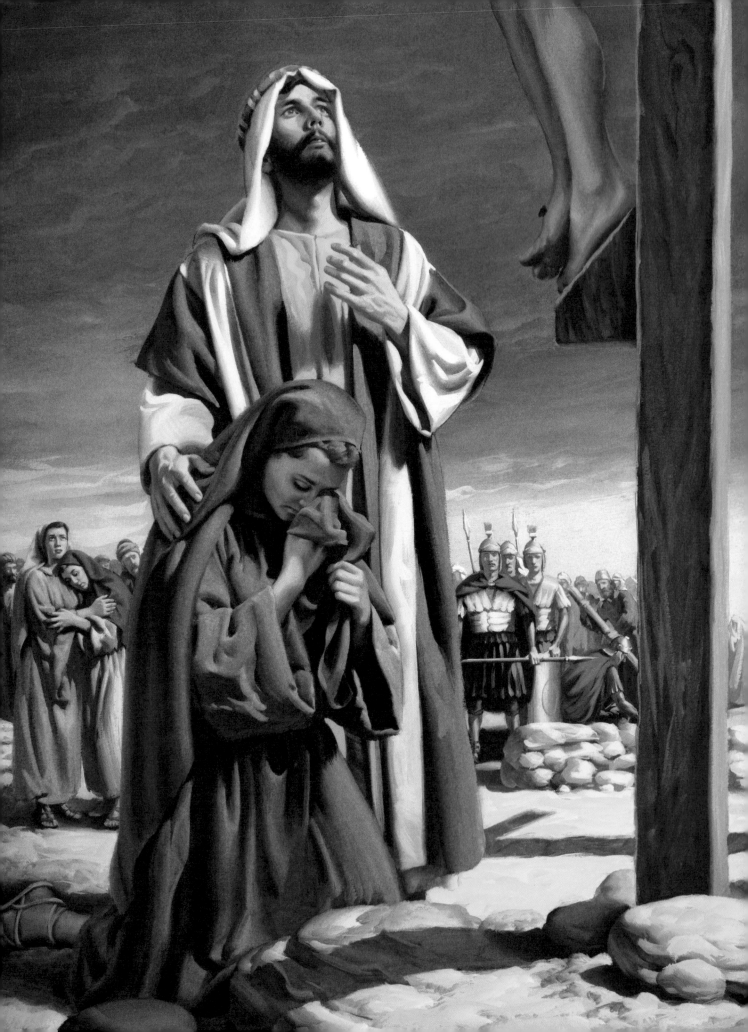

THE CRUCIFIXION
Luke 23:33–46

And when they were come to the place, which is called Calvary, there they crucified him, and the malefactors, one on the right hand, and the other on the left. Then said Jesus, Father, forgive them; for they know not what they do. And they parted his raiment, and cast lots.

And the people stood beholding. And the rulers also with them derided him, saying, He saved others; let him save himself, if he be Christ, the chosen of God. And the soldiers also mocked him, coming to him, and offering him vinegar, And saying, If thou be the king of the Jews, save thyself. And a superscription also was written over him in letters of Greek, and Latin, and Hebrew, THIS IS THE KING OF THE JEWS.

And one of the malefactors which were hanged railed on him, saying, If thou be Christ, save thyself and us. But the other answering rebuked him, saying, Dost not thou fear God, seeing thou art in the same condemnation? And we indeed justly; for we receive the due reward of our deeds: but this man hath done nothing amiss. And he said unto Jesus, Lord, remember me when thou comest into thy kingdom.

And Jesus said unto him, Verily I say unto thee, Today shalt thou be with me in paradise. And it was about the sixth hour, and there was a darkness over all the earth until the ninth hour. And the sun was darkened, and the veil of the temple was rent in the midst.

And when Jesus had cried with a loud voice, he said, Father, into thy hands I commend my spirit: and having said thus, he gave up the ghost.

THE RESURRECTION
Luke 24:1–12

Now upon the first day of the week, very early in the morning, they came unto the sepulchre, bringing the spices which they had prepared, and certain others with them. And they found the stone rolled away from the sepulchre. And they entered in, and found not the body of the Lord Jesus.

And it came to pass, as they were much perplexed thereabout, behold, two men stood by them in shining garments: and as they were afraid, and bowed down their faces to the earth, they said unto them, Why seek ye the living among the dead? He is not here, but is risen: remember how he spake unto you when he was yet in Galilee, Saying, The Son of man must be delivered into the hands of sinful men, and be crucified, and the third day rise again.

And they remembered his words, And returned from the sepulchre, and told all these things unto the eleven, and to all the rest.

It was Mary Magdalene and Joanna, and Mary the mother of James, and other women that were with them, which told these things unto the apostles. And their words seemed to them as idle tales, and they believed them not.

Then arose Peter, and ran unto the sepulchre; and stooping down, he beheld the linen clothes laid by themselves, and departed, wondering in himself at that which was come to pass.

JESUS REVEALS HIMSELF TO MARY MAGDALENE *by Providence Collection. Image © Goodsalt*

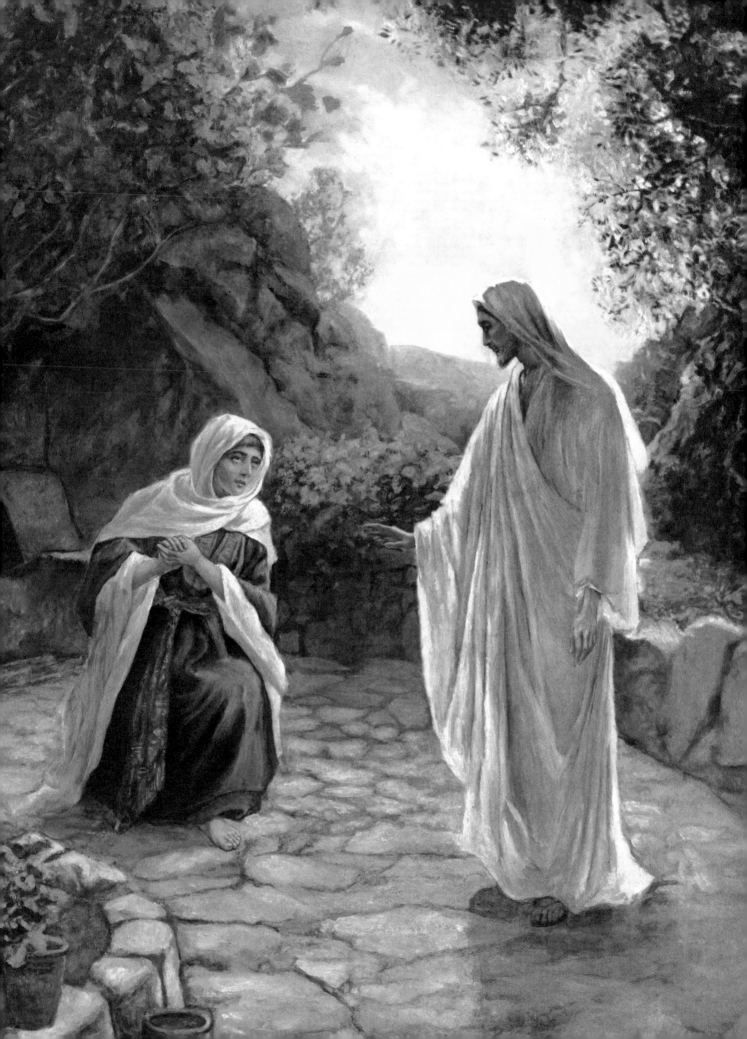

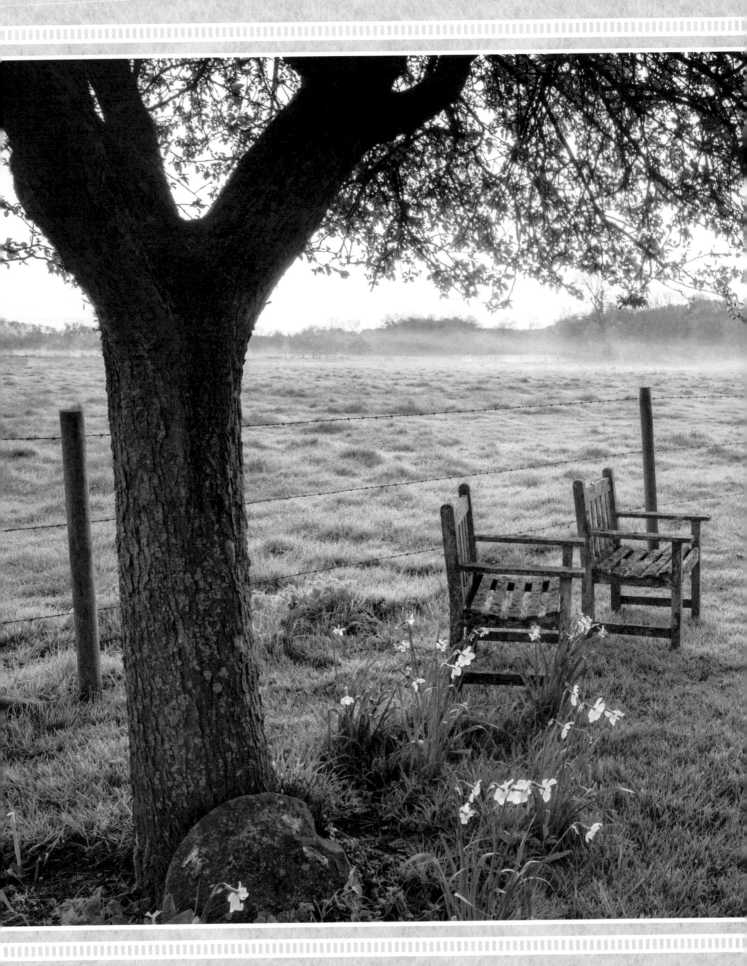

The Cry from Golgotha

Marcia K. Leaser

All alone on the windswept hill,
with teardrops in her eyes,
Mary knelt in silent prayer
and asked for strength that night.

Something had happened that
 very day
she didn't understand.
Jesus Christ—God's Son and hers—
fulfilled a mighty plan.

Somehow she knew the pain she felt,
though real as the rushing tide,
was nothing at all compared to this:
the wounded hands and side.

Suddenly, all she could do was ask,
"Oh, God, please tell me why.

He was so gentle, so
 kind and good—
how could You let Him die?"

Somewhere from out of the
 lonely night
came peace into her soul.
The reason Christ Jesus
 died was this:
so all could be made whole.

Still now, the wind and the
 teardrops too . . .
there is no need to weep.
The only thing left to
 do is wait.
He comes—for you and me.

Easter Day

Edgar A. Guest

They thought Him dead who
 saw Him die,
but that first bright Easter Day,
frightened Mary, drawing nigh,
found Death's great stone
 rolled away.

They who saw Him crucified
wept to see His body torn,
certain that the Christ had died
till that first glad Easter morn.

Doubt and dread and dismal gloom
terrified the minds of men

until Mary, at the tomb,
found that He had risen again.

Hope and faith and
 courage smiled
out of skies long dark and gray.
He, whom scoffers had reviled,
unto life had led the way!

Alleluia! now we sing.
Death all mortals can defy.
This the truth He
 came to bring:
all shall live who seem to die.

Image © Carole Drake/GAP Photos

The First Easter Morning

Rebecca Barlow Jordan

Early on the first day of the week, while it was still dark, Mary Magdalene went to the tomb and saw that the stone had been removed from the entrance.

—JOHN 20:1 (NIV)

The darkness surrounding the tomb early that morning matched the blackness of emotions filling Mary's heart, and confusion clouded her understanding. Jesus had stumbled and fallen under the excruciating load of a wooden cross on the way to Golgotha three days earlier. Broken and bleeding, He had endured the jeering and yelling of the angry mob around Him.

Mary had witnessed the black midnight at noonday and the thundering explosion as the earth shook beneath her feet on Friday—as if heaven had echoed its displeasure of the entire event. She wept as her precious Savior experienced an agonizing death by crucifixion on that ugly, splintered cross and as she watched the soldiers divide His clothes and cast lots for His robe. Later, she saw the place where Joseph of Arimathea had placed Jesus in the tomb, and she wept again until she was spent.

Saturday, the Sabbath must have seemed endless, as she waited until the morning when she could visit the tomb and anoint the body of her beloved Master with burial spices.

Then came Sunday. On the way, in the predawn hours, Mary Magdalene's eyes filled with tears again as she spoke to her companions, wondering who would roll away the stone. How could they complete their offering of love and honor for their precious Savior with the entrance sealed?

Would light ever shine in her dark heart again?

But as she approached the tomb, Mary couldn't believe her eyes. The stone over Jesus'

tomb had been rolled away? How? When? Further inspection revealed a startling truth: the tomb was empty!

It wasn't the sunlight from dawn that broke through Mary's darkness. Following the greeting of angelic messengers announcing Jesus' Resurrection to her and her companions, Mary saw the Light of the World Himself. Jesus appeared to her and was alive!

Before the sun had peeked over the horizon to announce the dawning of new day, the Son had risen. His death and Resurrection shouted a silent message to those who came to the tomb that first Easter morning: the dawning of a new era and a victorious, new life.

Image © age fotostock/Superstock

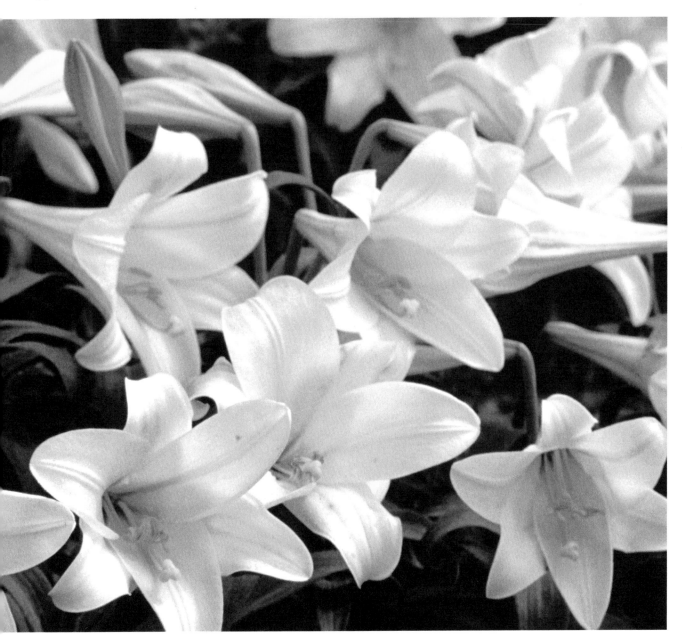

Easter Promise
Helen Williams

Remember that although the world
once witnessed Friday's cross,
the promised joy of Easter came
to end that night of loss,
so that the Resurrection morn
would never fail to be
the light of life that always robs
the grave of victory.

On an Easter Morn
Jessie Cannon Eldridge

Let me think deeply when the Easter comes;
look to my soul and weigh its faith and hope,
rededicate it; then lead those who grope
in unbelief into the light that sums
our living up in such a wondrous way;
show them the meaning of the Easter songs,
the lily flowers, the gathering of the throngs,
the hallelujahs; teach them how to pray.
We should be happy on an Easter morn,
rejoicing with Christ's glorious rebirth,
joining to spread His message around the earth
and beckoning others to again be born.

Call all who wander, who have sinned, known loss,
"Come, rise again, and conquer o'er the cross!"

My Easter Wish
Author Unknown

May the glad dawn
of Easter morn
bring joy to thee.

May the calm eve
of Easter leave
a peace divine with thee.
May Easter night
on thine heart write,
"O Christ, I live for Thee."

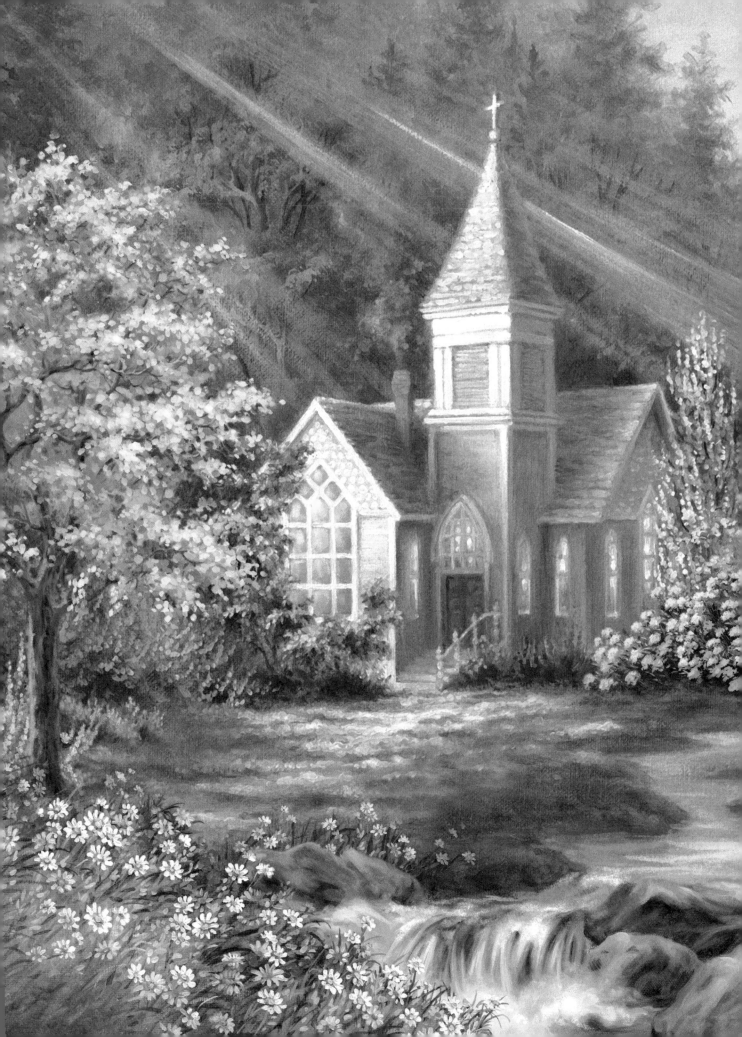

The Story of a Song

Strength out of Weakness

Pamela Kennedy

Easter is about overcoming—joy overcoming sorrow, hope overcoming fear, life overcoming death. Henry Lyte, the author of this familiar hymn, lived an Easter kind of life. Despite battling asthma and poor health, he faithfully pastored a small church near a garrison and fishing village in Devonshire, England, ministering to the fishermen, soldiers, and their families who worshiped in his parish. In fact, when questioned about his unwavering commitment to serve others in spite of personal hardships, he replied that he considered it "better to wear out than to rust out!"

In 1847, after twenty-three years in Devonshire, the devoted pastor received a diagnosis of tuberculosis. His doctor and friends convinced him to retire and travel to Italy, where they hoped the sunny weather might extend his life. On his last Sunday in Devonshire, once more overcoming his physical frailties and weaknesses, he delivered an impassioned sermon imploring his congregants to prepare for the time when they, too, would have to face their Maker. Returning to his study, he penned the verses of a poem he titled, "Abide with Me."

Shortly thereafter, Lyte began his trip to Italy. But the journey by ship and carriage proved too much and upon arriving in Nice, France, the ailing pastor could not continue. A few weeks later, on November 20, 1847, he died and was buried in the English cemetery at Nice.

But Lyte's hymn, "Abide with Me," would live on. Its hope-filled verses were translated into dozens of languages, and the deeply personal lyrics encouraged Christians across Europe and America. In 1947, on the one-hundredth anniversary of Lyte's death, letters poured in attesting to the comfort and assurance his hymn had provided in times of loss and deep despair. A group of ex-prisoners of war recalled how they sang the hymn each Sunday evening throughout their captivity during WWII. Survivors of the *Titanic* told of hearing the strains of "Abide with Me" sung by the remaining passengers on the sinking ship as it slipped beneath the sea. Belgian survivors of World War I reported that the words of the hymn were on the lips of British nurse Edith Cavell as she faced a German firing squad in 1915, condemned for her part in sheltering British, French, and Belgian soldiers.

Even today, after 170 years, Henry Lyte's hymn continues to speak to current generations about the overcoming power of faith. Reflecting on the words of Christ—"My grace is sufficient for you, for my power is made perfect in weakness"—we can almost hear Lyte respond along with the apostle, "For when I am weak, then I am strong" (2 Corinthians 12:9–10, NIV).

Abide with Me

Words by Henry F. Lyte

Music by William Henry Monk

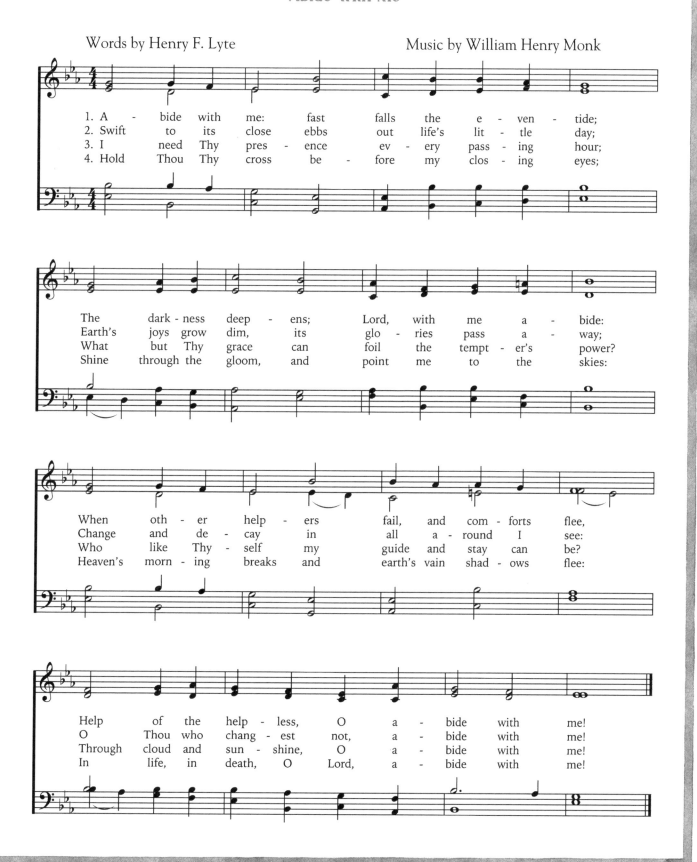

Joy of Easter Morning
Author Unknown

The mists of Easter morning
 roll slowly o'er the hills;
the joy of Easter morning,
 the heart of nature thrills.
The songs of birds are calling
 good people from repose
to sing of that first Easter,
 when Christ the Lord arose.

Upon a thousand altars
 are flowers of richest bloom,
proclaiming with sweet voices
 how Jesus left the tomb.
Nor shall our lips be silent
 by Joseph's empty grave;
wake, heart, and sing His praises
 who came the world to save.

He lives! No grave could hold Him.
 He broke death's cruel hands,
and now He reigns triumphant,
 the glory of all lands.
And north and south in anthems,
 and east and west in song,
through all this happy Eastertide,
 His praises shall prolong.

Image © John Glover/GAP Photos

Ode to a Dogwood Tree

Virginia Katherine Oliver

Every year when we behold
the wonders of the spring,
when flowers burst in bloom anew
and birds are heard to sing,

you lift your branches to the sky,
a modest little tree,
and hold your blooms so white
 and pure
for all the world to see.

Your snow-white blooms that signify
the purity of the One
Whose blood was shed for our sins
and said, "Thy will be done."

Perhaps there was a purpose
you should have been the tree
selected for the cross that stood
in shame on Calvary.

For each year when you
 bloom again,
you tell anew the story
of the Savior on the cross
Who rose again in glory.

You gently stir the hearts of men
to remind us of that spring
when souls of men shall live anew
where angel voices sing.

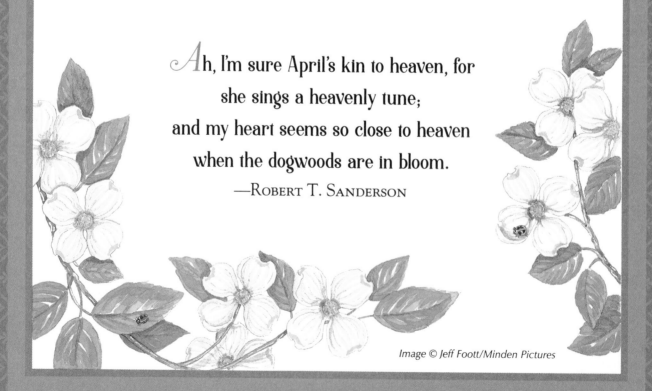

Ah, I'm sure April's kin to heaven, for
she sings a heavenly tune;
and my heart seems so close to heaven
when the dogwoods are in bloom.
—ROBERT T. SANDERSON

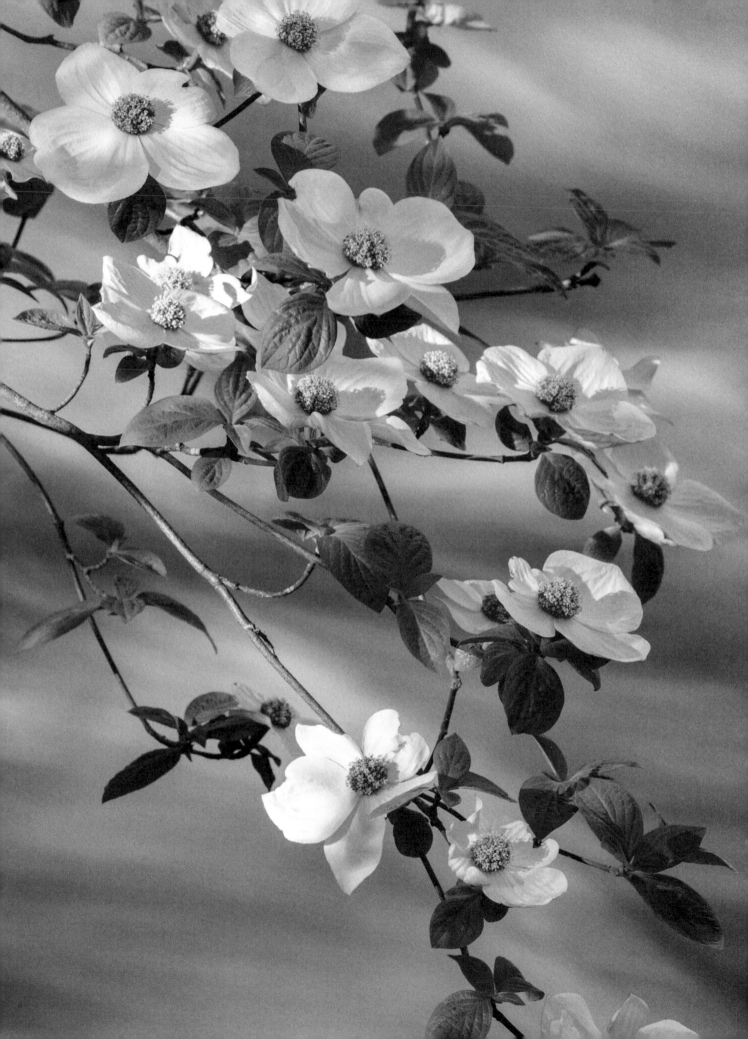

Through My Window

Seeing Spring

Pamela Kennedy

I've experienced more than seventy springs in a variety of locations and seasons of life. But I'd have to say that seeing it through the eyes of a grandchild is the very best way to experience the season. Because a young child sees spring through fresh eyes, there is wonder in every discovery.

For three-year-old Milo, a puddle is better than a water park! He races ahead of me outside his Chicago home, his dinosaur boots beating a tattoo on the sidewalk. Then comes the moment of launch as he's airborne for a couple of seconds before landing right in the center of the puddle. The splash soaks him up to his armpits with filthy water and splatters of mud. He grins, giggles, and yells, "Grammy do it!" I glance down at my clean sneakers and recently laundered jeans. I shake my head and smile. But Milo is not easily dissuaded.

"You could tee-RYE!" he insists, quoting his mother when she wants him to take a bite of some new food or persist when he gets discouraged. I laugh. I guess I could try! To Milo's delight, I take a couple of long strides and stomp through the puddle, splashing my shoes and the hems of my trouser legs. It's a small price to pay for his joyful giggle.

Puddle jumping is followed by worm gathering. Apparently, "Dis guy need some dirt." So we carefully pick up the wiggling creatures from the wet sidewalk and place them gently into flower-beds and pots. Milo is delighted. I'm a little disgusted. I dig an antibacterial wipe out of my tote bag and attempt to sanitize his little fingers before he jams them back into his mouth.

A hungry robin hops over and snatches one of our recently relocated earthworms. Milo stares, frowning. "What he doing?" I try to explain gently that robins like to eat worms, but they also feed them to their babies. Feeding babies seems to be a worthy destiny for a worm, so Milo shrugs and moves on.

"Grammy, how come dis guy so little?" He has yanked a crocus bud off its stem and is examining the tattered petals as he holds them up to me. We talk about how baby flowers need to be handled gently—and left to grow. He nods like he understands, but I'm not confident.

Farther along, Milo spies the bright blue of a broken eggshell on the sidewalk. He picks it up and examines the flecks of yolk still inside. "What dis guy?" he demands. How did a simple walk after a spring shower get so complicated? I describe how birds lay their eggs in nests high up in trees and how sometimes a strong wind comes along and the branches sway. Perhaps this is what caused this tiny egg to fall down and break on the sidewalk. He ponders for a moment. I worry about him having to learn about life and death at such a

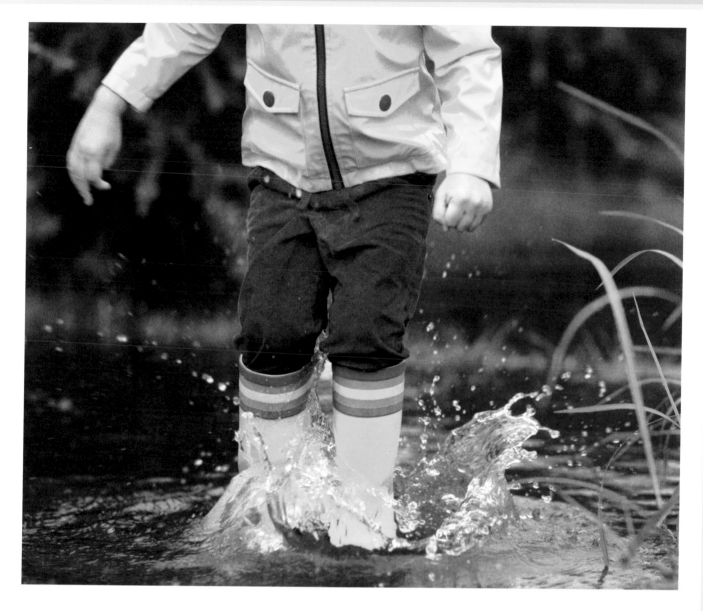

young age. Then he puts his little thumb into the blue piece of shell and holds it up to me. "Kinda like a helmet," he pronounces, smiling proudly. I guess I needn't have worried. Not only do three-year-olds have insatiable curiosities, but they also have the attention spans of gnats! Out come the sanitizing wipes.

Our walk continues along under dripping leaves. Milo chatters on about everything he sees. He picks up bugs and sticks and abandoned gum wrappers. We find a penny and watch a sparrow take a bath in a puddle. A squirrel hops in front of us, dashes up a tree, and sprints across an overhead wire onto a rooftop. "Dat guy real, *real* fast!"

Milo declares, laughing. He decides to imitate the squirrel, hopping onto a wooden beam edging a garden. After a few steps, he stumbles, falls down, and looks up. "I can tee-RYE some more." I hold his damp little hand in mine, and he walks the length of the beam. He grins at me.

This is spring with a grandchild. It is remembering that big things were once small. That everything grows and changes. That life is always moving toward the next discovery. That joy is all over, free for the taking. And that sometimes, when you stumble, you just have to get up, reach out for a loving hand, and "tee-RYE" one more time.

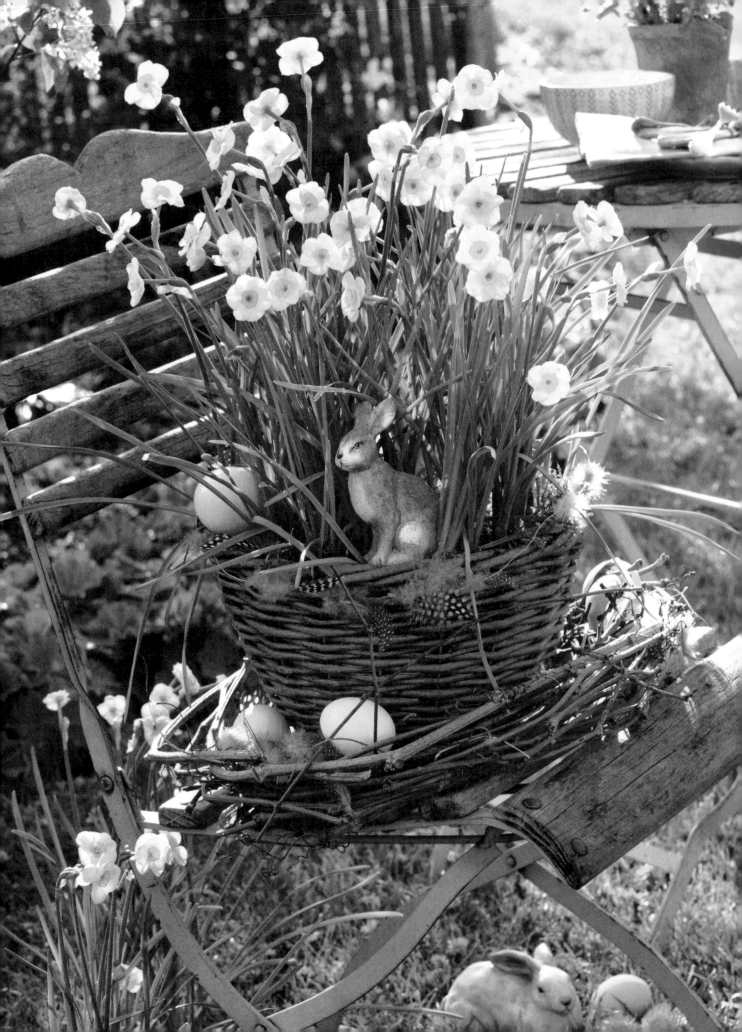

My Day Off
Edna B. Hawkins

I planned to clean the house today
and store all the winter things away,
but a little girl called out merrily,
so my task must wait till she's tired of me.

I thought I'd polish all the floors
and finish a hundred household chores,
but a little boy wanted a story read,
his dinner cooked, and his puppies fed.

A brown thrush down in the woods nearby
called me to look at God's blue sky,
and the sunshine, warm on her joyful way,
begged me with all of her heart to stay.

With fields full of clover and the apple trees,
the rosy richness of a springtime breeze,
I forgot all the work that I'd planned to do
and just sat in the meadow till day was through.

Why the tasks aren't finished, I can't explain;
I try to feel sorry, but all is in vain.
For the rapture I've known, I just wouldn't miss,
for no day will be as happy as this.

April Days
Edna Jaques

Time to turn things out for spring.
Brighten up the walls and floors,
polish windows till they shine,
put new varnish on the doors,
paint the cupboards bright and new . . .
let the winds of spring blow through.

Time to get out fishing gear,
rod and flies and shiny reel,
find a brook that sings along,
where a tired man can feel
all the magic of the earth
in the warmth of springtime birth.

Time for little boys to fly
soaring kites and tangled string,
cutting circles high and wide
in the bright blue skies of spring,
spilling laughter as they run
in the glory of the sun.

Time for people everywhere
to be up and out of doors,
climbing hills that reach the sky
where the golden sunlight pours
all its warm, health-giving rays
in the lap of April days.

Out with the Old

Anne Kennedy Brady

My husband smiled gingerly, as if approaching some unpredictable jungle cat. "I want you to keep anything that's really important to you," he reassured me, gesturing toward two plastic crates bulging with memorabilia from the last two decades of my life. "But maybe we could get it down to one box?"

I am not the tidy one in our marriage. Kevin has "homes" for everything: keys by the front door, bills in the stairway file box, etc. He rarely picks up souvenirs, and he tosses birthday cards with admirable abandon. Meanwhile, I have Christmas cards from four years ago and can never find my umbrella on the first try.

However, once a year, I indulge him in spring cleaning. I have to admit it feels good to toss old magazines, organize the coat closet, and fill a bag with clothes to give away. And I've surprised myself with how much easier the process is with a yearly tradition in place. So much so that, once April peeks around the corner, I've been known to grab a trash bag of my own volition and start scavenging for outgrown detritus unprompted.

The memory boxes managed to avoid our annual springtime purge, until last year. We were in the process of rearranging our downstairs to accommodate a second baby, due in October. In a matter of weeks, my parents would be arriving to move the guest room, paint a nursery, assemble a crib, and manage whatever else we could do in ten days. In preparation, Kevin and I needed to relocate any storage items into a tiny, odd-shaped under-stair closet. Two giant crates wouldn't make the cut.

So one sunny afternoon, while my three-year-old napped, I popped open the lids and got to work. While I'd added steadily to the collection through the years, I'd never sat down and gone through the whole thing. I soon lost myself in photos from college study-abroad trips, my first Easter breaks away from home, and early acting jobs. The scent of spring flowers wafted through an open window as I lingered over the image of a friend gone too soon and smiled at a postcard Kevin had sent me when we were first dating. Project "Reduce the Crates" was not going well. Then, about an hour in, the whole effort came to a complete standstill when I reached the wedding and baby levels. I sent a desperate text to my mother.

"I think I need someone to give me permission to throw out some memories. Will you be that person?"

She responded immediately. "Read the notes one more time," she wrote. "Enjoy the pictures, feel grateful, and then release them. It's freeing, I promise!"

I looked at the stacks of paper surrounding me. A flicker of motion drew my eye to the window, where a red-breasted robin had been watching the proceedings with interest. He cocked his head at me, then flew off. I smiled. Freeing myself sounded nice. With a deep breath, I dove in.

First to go were old audition pieces for roles I was now too old to play and notes from classes I'd completed a decade ago. I read through cards

Image © Dan Duchars/GAP Photos

from my thirtieth birthday (six years ago), laughed at the sentiments, and chose one or two to keep. I decided I needed neither ten copies of our wedding invitation nor a dozen programs. I admitted I could live without the seamstress's notes from my dress fitting. And while a few cards from my son's baby shower featured long notes from loved ones, most were simple (while heartfelt) well-wishes that were never meant to live in a box for years. Out went the wedding RSVP cards, the menu from our first anniversary, "We've Moved!" postcards, and paperwork from the hospital birth classes. Release, release, release.

I kept some of the big stuff. A poster from a favorite play. A pressed flower in an Easter card from my grandmother. A funny photo of my college roommate. The card Kevin gave me the day before we married. My dad's wedding toast. A clay impression of my son's infant footprint. An ultrasound image of his forthcoming baby sister. But by dinnertime, I proudly presented my husband with just over half of one crate of memories.

While impressed, he was worried I'd regret losing so much. "You should keep some more!" he insisted. But I shook my head. Somewhere between eight-year-old gift receipts and torn newspaper clippings, I'd realized my mother was right. This process of clearing space was more than just spring cleaning. I felt like that robin: free. Free to celebrate my past without incidental clutter. Free to say goodbye to parts of myself that no longer felt relevant. And most of all, free to prepare for our next chapter, while still honoring the stories that got us here.

Dandelion Days
Keith H. Graham

On a flowery, showery
Easter Sunday,
delightful dandelions
spring up on display.

They grow by hundreds
under blossoming trees;
they sparkle in sunshine
and bob in the breeze.

On a gray fence post,
a robin sings cheerfully,
"Cheer up, cheerily."

A sister and brother
venture outdoors to play
and to pick "gold nuggets"
for a springtime bouquet.

With a pink umbrella
and a basket in hand,
the girl skips and twirls
across the fairy-tale land.

Beside a wooden feeder,
a chickadee sings merrily,
"Chickadee-dee-dee-dee."

Dressed in bare feet
and grass-stained knees,
the boy gathers "gold coins"
under white-flowering trees.

In Spring
Eileen Spinelli

In spring
the gardener digs
in the soft, brown earth.
And the poet
gathers
scattered words
into eloquent bouquets.

In spring
the dancer sways barefoot
in tender grass,
and a daisy-faced child
romps in a puddle.

In spring
the workman sings,
his voice threading through
robin song.
And a girl sets out
on her bike
to follow her heart.

Image © Friedrich Strauss/GAP Photos

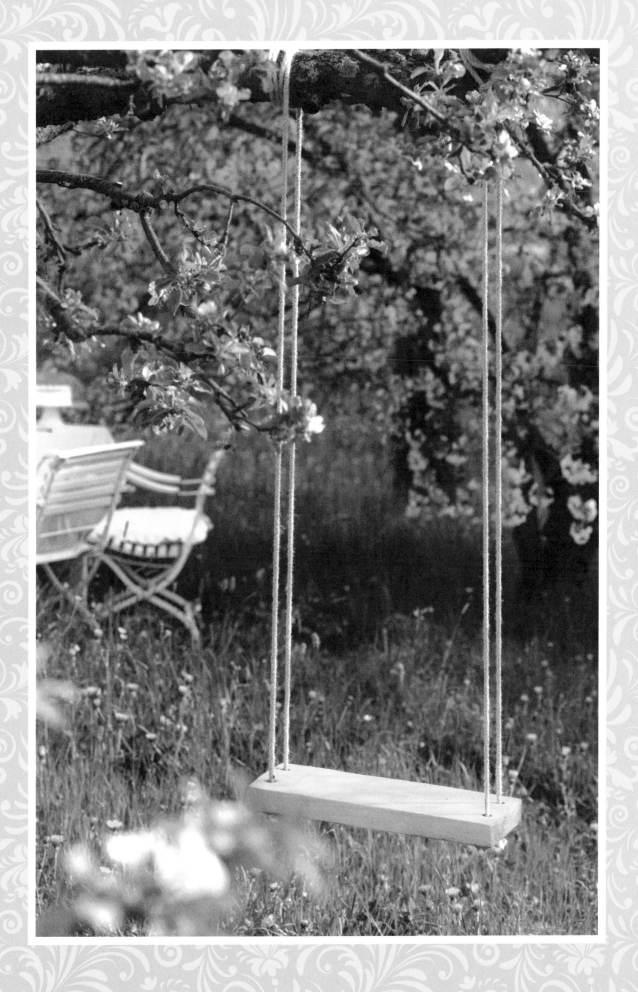

Bits & Pieces

Earth laughs in flowers.
—Ralph Waldo Emerson

There are always flowers for those who want to see them.
—Henri Matisse

In the spring, at the end of the day, you should smell like dirt.
—Margaret Atwood

Show me your garden, and I shall tell you what you are.
—Alfred Austin

Spring has returned. The earth is like a child that knows poems.
—Rainer Maria Rilke

To plant a garden is to
believe in tomorrow.
—*Audrey Hepburn*

Who loves a garden
loves a greenhouse too.
—*William Cowper*

Flowers are the sweetest things God
ever made and forgot to put a soul into.
—*Henry Ward Beecher*

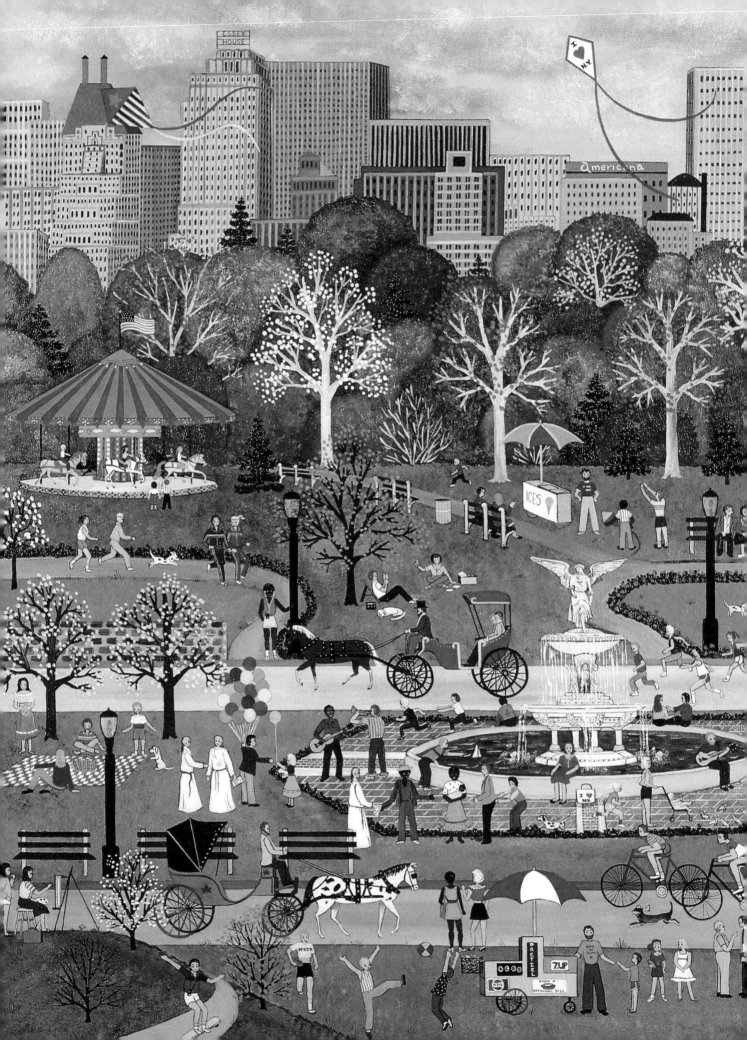

Spring Journey
Ruth B. Field

Spring on a string goes sailing high,
buoyant and gay to wander
over the airways to the sky
into the great blue yonder.

Unleased by the hand of one small boy
whose heartbeat in rhythm swings

far into space—the old, old joy
passed down through countless springs.

Its trailing tail in windborne flight
as it climbs to the skylanes blue,
a boy sends aloft his magic kite,
and his dreams go soaring too.

Kites
Kay Hoffman

Kites are flying overhead.
Some are blue, and some
 are red!
Sailing on the clouds so high,
way up in the pink-blue sky!

Winds are singing,
 "Come and play;

let me fly your kite away.
Boys and girls, come,
 let's have fun.
I'll fly your kite up to the sun!
Then, I'll let it drift
 back home,
and you will have it
 for your own!"

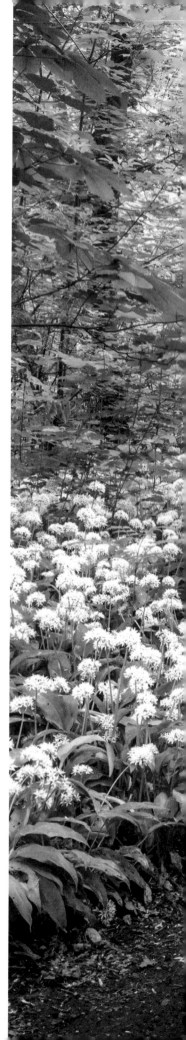

Thanks for Springtime
Arthur L. Fischer

I thank Thee, Lord, for brooks so blue
that as a child I waded through;
for violets beside the rills,
and on the hillside, daffodils;

the robins in my apple trees
that wake me with their melodies;
for azure skies, for pastures green,
all loveliness my eyes have seen.

For life and love, the urge to sing . . .
I thank Thee, Lord, for everything!

To Life
Susan Sundwall

While walking in the
 wood one day
with springtime all around,
I heard a kind of melody
rise gently from the ground.

It soon was echoed in the trees;
it burst from bud and flower.
I threw my head back in delight
and down came heaven's
 sweet shower.

I skipped, enchanted,
 through that rain,

and once more realized
that everything God has made
was right before my eyes.

The woodland mist,
 the meadowlark,
the wax and wane of moon,
the rolling fields and dandelions
all nodding to the tune.

To life! To life! it sang to me—
to every living soul.
His gift of life is offered here
and makes us, each one, whole.

Image © Franci Suffle/Shutterstock

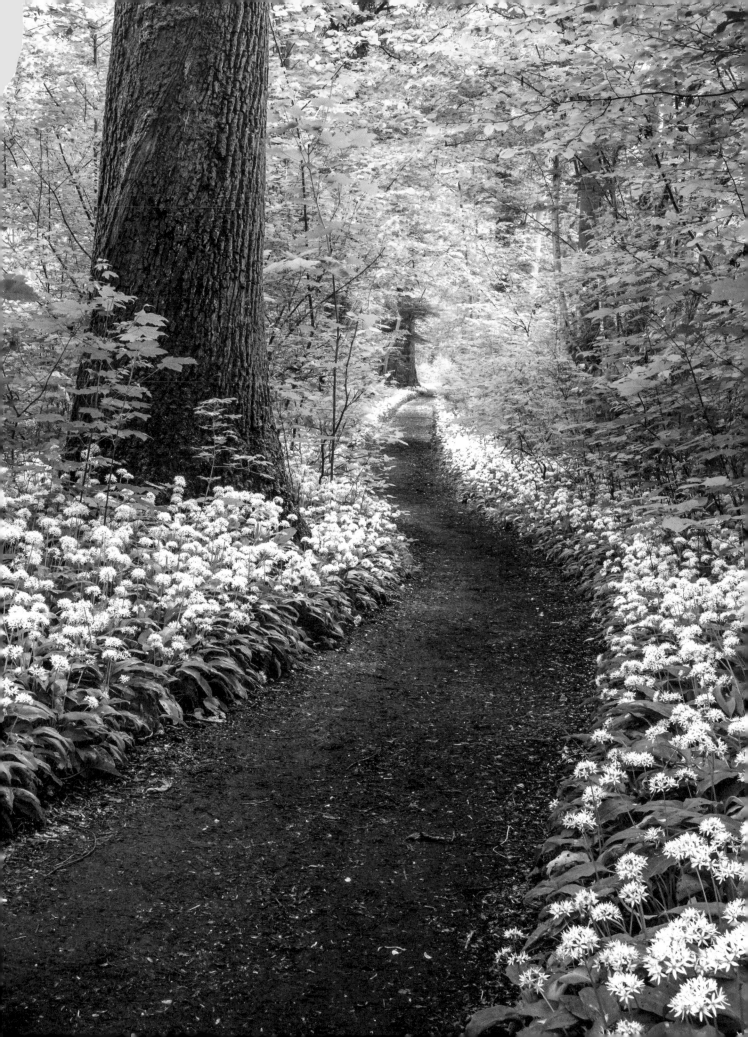

Easter Greetings

Marian L. Moore

May the wondrous Easter story
thrill your soul with hope anew,
bringing all God's richest blessings
in the springtime just for you.

ISBN: 978-1-5460-1455-3

Ideals
Hachette Book Group
1290 Avenue of the Americas
New York, NY 10104

Printed and bound in the U.S.A.

Publisher, Peggy Schaefer
Editor, Melinda Rathjen
Designer, Marisa Jackson
Associate Editor, Kristi Breeden
Copy Editors, Rachel Ryan, Rebekah Moredock

Cover: Image © Friedrich Strauss/GAP Photos
Inside front cover: *Springtime Melody* by Kim Norlien. Image © Kim Norlien/MHS Licensing
Inside back cover: *Picket Line Blues–Ruby-throated Hummingbirds* by Susan Bourdet. Artwork provided courtesy of the artist, Wild Wings, and Art Brand Studios. www.wildwings.com. 800-445-4833. All rights reserved.

Sheet Music for "Abide with Me" by Dick Torrans, Melode, Inc. Art for "Bits & Pieces" by Linda Weller.

Want more seasonal poetry, inspiration, and art? Be sure to look for our annual edition of *Christmas Ideals* at your favorite store.

Join the community of *Ideals* readers on Facebook at: Facebook.com/IdealsMagazine

Readers are invited to submit original poetry and prose for possible use in future publications. Please send no more than four typed submissions to: Hachette Book Group, Attn: *Ideals* Submissions, 6100 Tower Circle, Suite 210, Franklin, Tennessee 37067. Editors cannot guarantee your material will be used, but we will contact you if we do wish to publish.

ACKNOWLEDGMENTS

HOLMES, MARJORIE. From "Love and Laughter." Copyright © 1967. Used by permission of Dystel, Goderich & Bourret LLC. All rights reserved. OUR THANKS to the following authors or their heirs for permission granted or for material submitted for publication: Georgia B. Adams, Susan Andrus, Anne Kennedy Brady, Clara Brummert, Lansing Christman, Carol Dismore, Joan Donaldson, Jessie Cannon Eldridge, Ruth B. Field, Arthur L. Fischer, Keith H. Graham, Edgar A. Guest, Jeris Hamm, Rachel Hartnett, Edna B. Hawkins, Michael Heaton, Mabel F. Hill, Kay Hoffman, Edna Jaques, Rebecca Barlow Jordan, Pamela Kennedy, Minnie Klemme, Gertrude Kline, Marcia K. Leaser, Peggy Mlcuch, Marian L. Moore, Virginia Katherine Oliver, Robert T. Sanderson, Florence K. Snethen, Eileen Spinelli, Susan Sundwall, Carice Williams, and Helen Williams.

Scripture quotations, unless otherwise indicated, are taken from the King James Version (KJV). Scripture quotations marked NIV are taken from the *Holy Bible*, New International Version®, NIV® Copyright © 1973, 1978, 1984. 2011 by Biblica, Inc.® Used by permission. All rights reserved worldwide.

Every effort has been made to establish ownership and use of each selection in this book. If contacted, the publisher will be pleased to rectify any inadvertent errors or omissions in subsequent editions.